Classic Game Room®
PUBLISHING EMPIRE

How To Draw Digital
By Mark Bussler
Copyright © 2019 Inecom, LLC.
All Rights Reserved

2019 Revised Edition

Written and drawn by Mark Bussler

No parts of this book may be reproduced or broadcast in any way without written permission from Inecom, LLC.

www.ClassicGameRoom.com

Classic Game Room®

How to Draw Pandas by Mark Bussler

Ethel the Cyborg Ninja #2

How to Draw Dolphins by Kawaii Ocean

TABLE OF CONTENTS

04 - About the Author

06 - **Chapter 1: Overview**
07 - What is Digital Drawing?

12 - **Chapter 2: Drawing Tools**
13 - Pencil, Paper, & Phone
16 - Flatbed Scanner
18 - Smart Tablets
21 - Digital Pens
24 - Graphic Tablets
29 - iPad Pro
30 - Wacom Cintiq

33 - **Chapter 3: Software**
34 - Free Drawing Apps
39 - Adobe Sketch and Adobe Draw
41 - Autodesk SketchBook
43 - ProCreate
44 - Clip Studio Paint Pro
50 - Adobe Photoshop
55 - Adobe Illustrator

56 - **Chapter 4: Digital Drawing Basics**
58 - Hand Position, Lag, & Spacing
60 - Sketching and Inking
64 - Drawing in Layers
70 - Drawing with Photo-Tracing Assistance
73 - Draw by Zooming In
74 - Putting It All Together

82 - **Chapter 5: Advanced Workflow**

84 - Storyboard
86 - Modeling and Penciling
91 - Inking
92 - Finishing
98 - Publishing

102 - **Chapter 6: Practice**

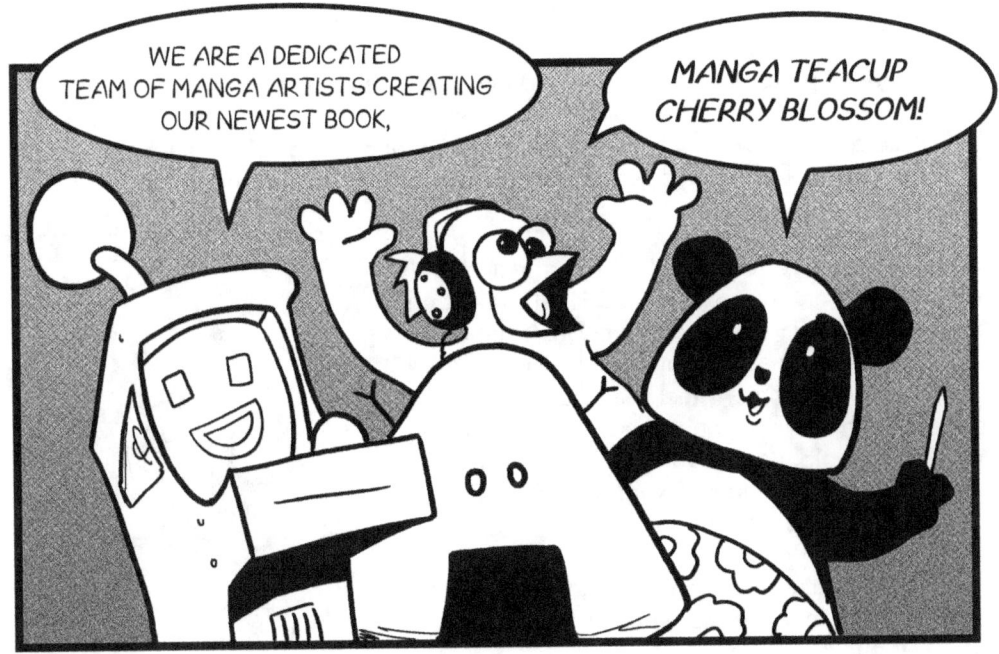

ABOUT THE AUTHOR

Greetings, I'm Mark Bussler, and I'll be your writer and artist through this fantastic journey into the world of digital drawing. I created this book because digital drawing is an art form in and of itself, and the gateway to self-publishing freedom and modern artistic expression.

Let me tell you a bit about myself; I grew up in the 80s and learned to draw with pencils and pens by copying comic strips and comic books. I was good but discovered that it requires more than talent to become a professional artist. As an adult, an art career requires sacrifice, practice, luck, and a willingness to learn new technology. I went to school for business rather than art (because getting a job in art is nearly impossible), but art has always been my passion, and now I'm fortunate to do it as a career.

After earning a degree in marketing, I drew comic books as a hobby, learned Photoshop, and built websites in the 90s. From there I worked in advertising and print media. In 1998 I nearly had a syndication deal for my comic strip Mass Media, but it fell through, and I ended up in websites instead (probably a good move.) In 1999 my advertising and web career morphed into video, and I used my comic book drawing for storyboarding but discontinued by cartooning and comics ambitions for the next 14 years.

Between 2000 and 2007, I produced documentary films and moved full-time into Internet video with Classic Game Room in 2008 (which continues to run to this day.) For more than a decade I traded in pencils and pens for video cameras and editing. Internet self-publishing was my future, though I didn't expect to be in print!

In 2014 I picked up my pencils and pens once again to publish a book called Lord Karnage the old fashioned way. I drew it with pencil and ink and scanned it. Lord Karnage was a challenge and took too long to produce. In a world where things move faster, I decided to learn more about digital drawing to speed up my process.

In 2015 I invested in a Wacom Cintiq and drew my next graphic novel called Ethel the Cyborg Ninja digitally from start to finish. It took a full year to get the hang of digital drawing which has a very different feel than pencil on paper! From there I have published dozens of comics, guidebooks, and tutorials using various digital drawing techniques. I continue to learn new tools and processes to this day.

Drawing digital is great fun but also efficient, and efficiency is essential in the world of self-publishing. Enjoy!

Mark Bussler modeling for Lord Karnage.
Photo taken with iPad Pro.

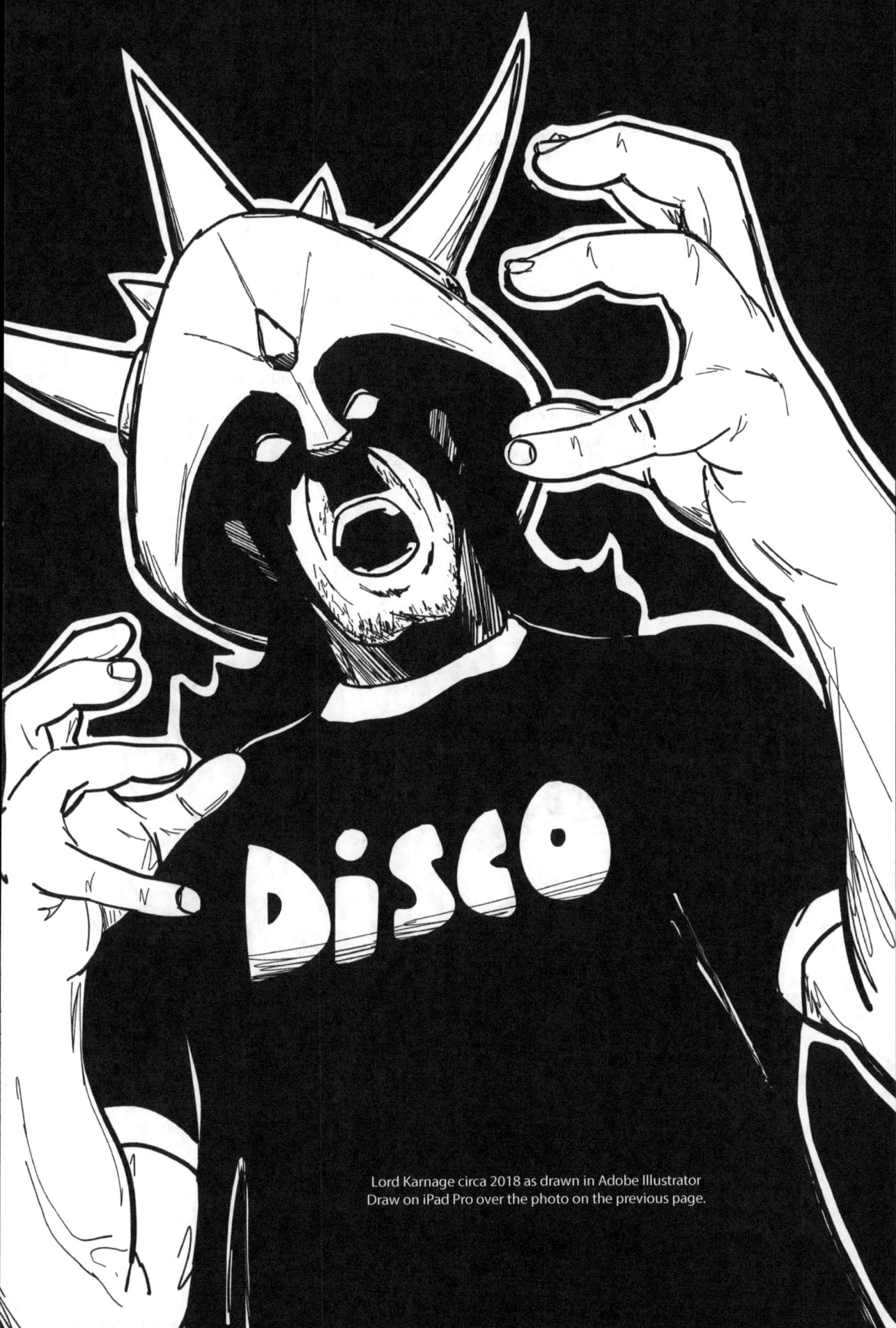

Lord Karnage circa 2018 as drawn in Adobe Illustrator Draw on iPad Pro over the photo on the previous page.

CHAPTER 1: OVERVIEW

This book is for anyone of any skill level who wants to learn how to draw digitally with tablets, touch screens, computers, iPads, and modern drawing software.

Additionally, this book is for anyone who wants to share their drawings and artwork with friends, family, social media, customers, or publishers. Your digital drawings are only a few clicks away from the rest of the universe; it's time to start publishing your work, even if it's just for fun!

Drawing digital won't necessarily make you better at drawing, but it will give you access to tools that increase your creativity and productivity. Your artwork will be easier to share online or prep for self-publishing if it starts and ends on the computer or smart tablet. Art is great fun for all ages, and we'll learn the tools, tips, techniques, and tricks to harness the power of technology to expand your creative vision!

2019 revision notes: I first published this book in early 2018, but digital tools and technology move fast. This revision includes a section on ProCreate, I added new artwork from my most recent books and added some new social media platforms like TikTok to use for exposure.

Mark sketches a two-page spread for an upcoming **Ethel the Cyborg Ninja** book on iPad Pro using Adobe Draw and the Apple Pencil.

WHAT IS DIGITAL DRAWING?

Digital drawing is very similar to physical drawing with pencils, pens, charcoal, markers, and crayons; it is also completely different at the same time and always changing. This book is not about fighting change; it is about embracing it. I love old-school art; it required more talent to make. But digital art is practical and efficient, and in today's fast-paced world, practicality and efficiency win every time.

As I see it, digital drawing means starting and ending a drawing (or any work of art) on an electronic device that replaces traditional physical media like paper, Bristol Board or canvas.

There is no right or wrong way to draw; everyone does it differently. The point of this book is to guide readers and artists in the right direction by opening minds to the best tools and techniques, many of which are free.

Drawing digitally into a computer or tablet is beneficial for a long list of reasons. It is, in most respects, faster and more efficient than traditional physical media. No longer do cartoonists need to clean up their mistakes with "white out," digital tools have rendered that obsolete. However, tablets and computers don't have the same feel as traditional physical media.

Artists are creatures of habit, and this change from physical to digital can be a complex and often frustrating process.
Digital drawing tools can cheapen art in the same way that video has destroyed film; every shot is free, so why not film a lot of it? However, when used properly, these modern tools can make your finished work look better, speed up workflow, and allow you to reach a wider audience with ease.

Be wary that one can quickly fall victim to the shortcuts that digital drawing offers; plagiarism, for example, runs rampant on the Internet. We're not here to copy drawings stolen online; we're here to make art based on our ideas, creations, and photographs.

Drawing for fun is an incredible hobby, and drawing digital can assist with that hobby. After an initial small investment, the move to digital costs less and makes sharing with friends far easier.

Professionally, it is a different story. Modern art software and technology continues to change the landscape for better and worse. The tools are so good now that comic books can practically draw themselves; this has put a lot of artists and related careers in the comic book industry out of work, but it also allows for self-publishing opportunities that were science fiction just a few years ago.

"What is digital drawing? It's... like drawing on computers and stuff."

PROS AND CONS OF DRAWING DIGITAL VS. DRAWING PHYSICAL

Pros.	Cons.
• Faster publishing	• Cheapens the art
• Save instantly	• Prone to deletion
• Draw in layers	• Possible high startup costs
• The undo button	• Reliance on the undo button
• Zoom in and out	• Doesn't feel like paper
• Infinite brush strokes	• Can't sell digital originals
• No more white out	• Greasy hands on screens
• Speed up creating	• Lag
• Digital camera assistance	• Digital camera assistance
• No more eraser dust	• Battery life
• The iPad!	• Kids dropping the iPad
• Computers are rad	• Computers are evil

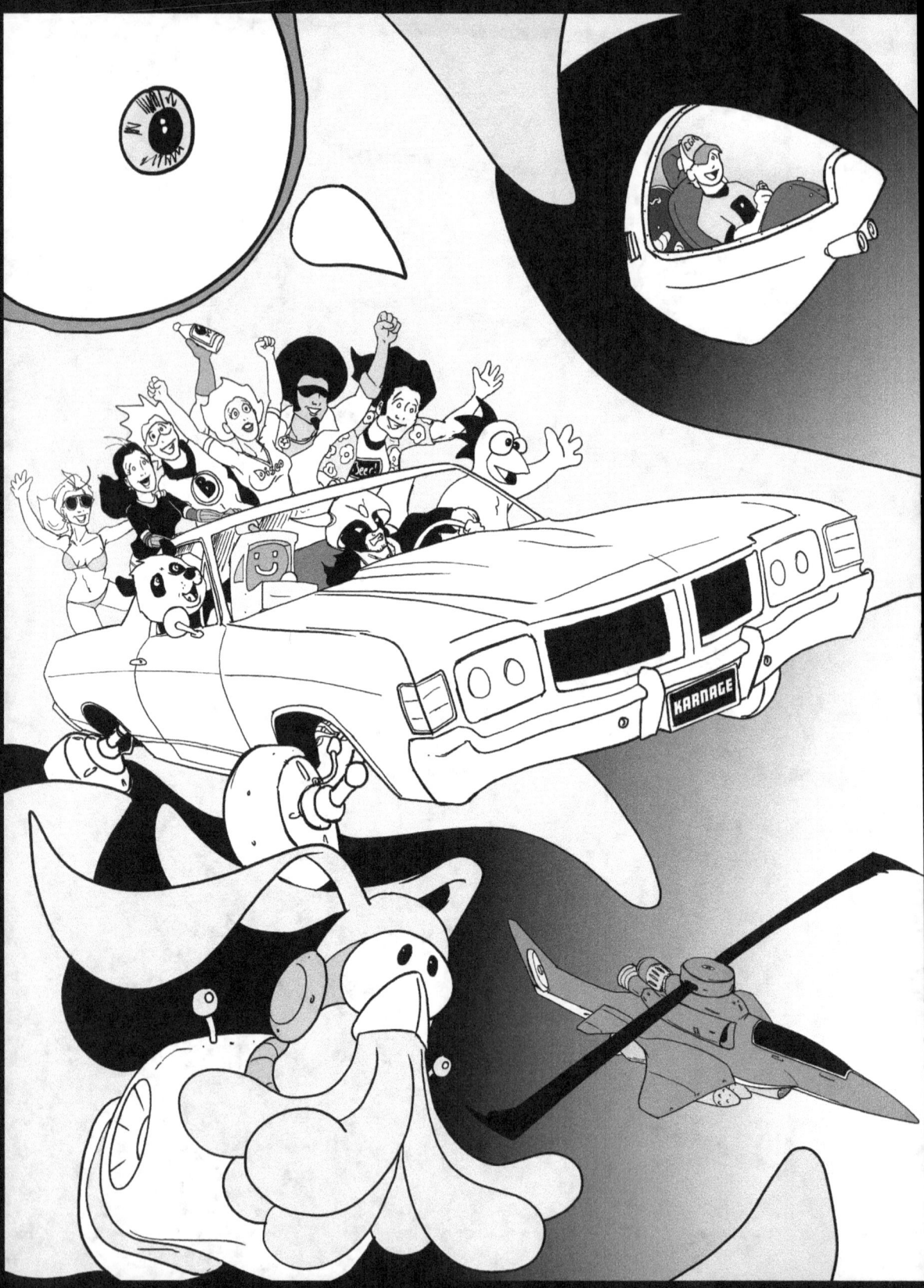

A two-page spread from my book **Retromegatrex** that was started on iPad Pro and finished inside Adobe Photoshop on my Mac desktop using a Wacom Cintiq.

CHAPTER 2: DRAWING TOOLS

Innovation drives new techniques. Advances in digital drawing technology are no different than advances in oil painting materials hundreds of years ago.

No longer do cartoonists need to drain Sharpies when filling in black areas on paper, a click of the Photoshop bucket tool will do the job; it saves money and time (and precious Sharpie markers.)

The proper tools allow artists to express themselves. Advances in technology can assist in creating and increased productivity.

I organized this section by budget, starting with the most affordable digital drawing tools and working up to the most expensive professional setups that cost many thousands of dollars.

When you or your kids are starting, I recommend buying only the basics. Start with an entry-level tablet, free software and work up to the more advanced, more costly options.

Give your brain and your hand time to adapt and never spend more than you need to. The price of the tools does not guarantee improved results. In most cases, more complex tools and advanced software lead to a greater chance of error and frustration (and a much greater learning curve.) Photoshop is much harder to use than ProCreate, for example.

Additionally, as a parent of young children, I am mindful of the way that kids can treat expensive tablets. Nobody wants to see their $1000 iPad Pro tossed across the room or sketched on with a screwdriver. Start with something cheap and a screen protector or padded case!

TOOLS INCLUDED IN THIS SECTION

- Pencil and Ink
- Paper
- Smart Phone
- Flatbed Scanner
- Smart Tablets
- Digital Pens
- Graphic Tablets
- iPad Pro
- Wacom Cintiq

PENCIL, PAPER & PHONE
- $ -

Do not underestimate the power of your smartphone; it is the gateway to everything that the Internet has to offer, and it has a good camera. The phone that you already own can publish your artwork as easily as a $10,000 Mac Pro computer setup. It's the best place to start.

Therefore, the first digital tool that I recommend is a pencil and paper. Art created with a pencil and paper isn't digital until photographed with a camera, thus making it digital. Crayons and markers will also suffice.

This technique will likely use tools that you already have, which means that you should not have to spend anything to get your feet wet in the world of digital publishing. Draw pictures on paper and photograph them for preservation or digital modification.

Preserve your kids' artwork by photographing it, saving, and uploading it to cloud storage. Share their art with friends on social media or enhance the drawings digitally by using free tools from the app store.

This hybrid digital-physical technique is particularly useful for those of you with really young kids who love crayons and paint. Kids should be kept as far away from that fancy new iPad as possible!

The resolution of modern smartphone cameras is more than capable of capturing a drawing with incredible detail. With a bit of practice, you'll be able to snap a shot worthy of preservation or additional digital effects work.

I have used this technique numerous times to photograph a rough pencil sketch and turn it digital for later refinement. Consider that you can draw an idea on a napkin over lunch, photograph it, and then turn it into published work later that day.

When taking a picture of a sketch, make sure to position your camera directly over the drawing and photograph it straight down to eliminate any distortion. I suggest taking a few pictures to give yourself some options, digital photos as free!

For sharp pictures, do your photography in a well-lit room with a light source in front of you. Hold your phone directly over your drawing and rest on your elbows, tap the screen for focus. Prevent the phone's shadow from getting on the paper by facing a light source such as a window or lamp.

After taking a few pictures, preview them by zooming in to make sure they're sharp and then "save".

This is a very useful and efficient process for those of us who love the feel of real-world sketching on paper but rely on digital inking and effects work. Make the digital photograph a draft layer in Photoshop (or Adobe Sketch and ProCreate) and ink over it in a separate layer, a technique I cover in more depth on page 64.

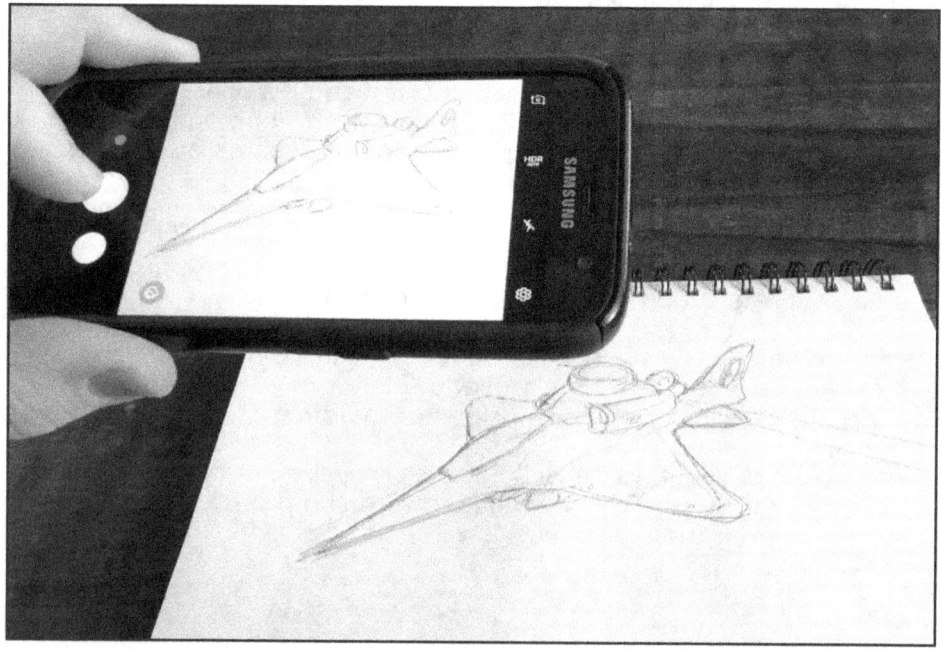

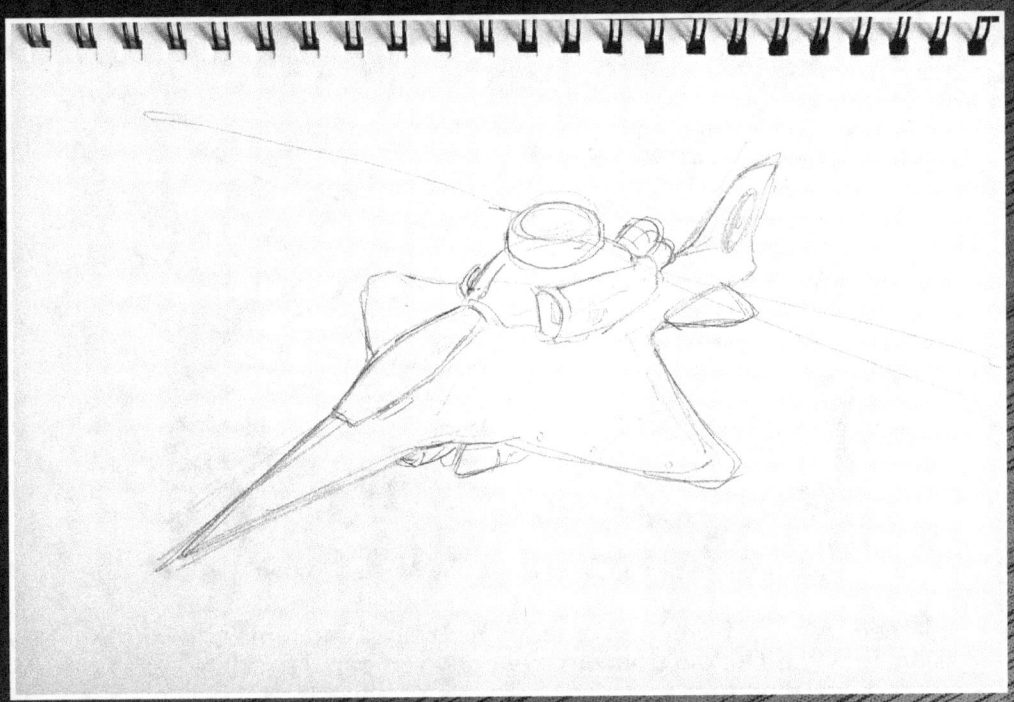

This pencil sketch of the Magnum 9000 helicopter from **Magnum Skywolf** was photographed on my dining room table, sent to my Mac and inked inside Photoshop with Wacom Cintiq.

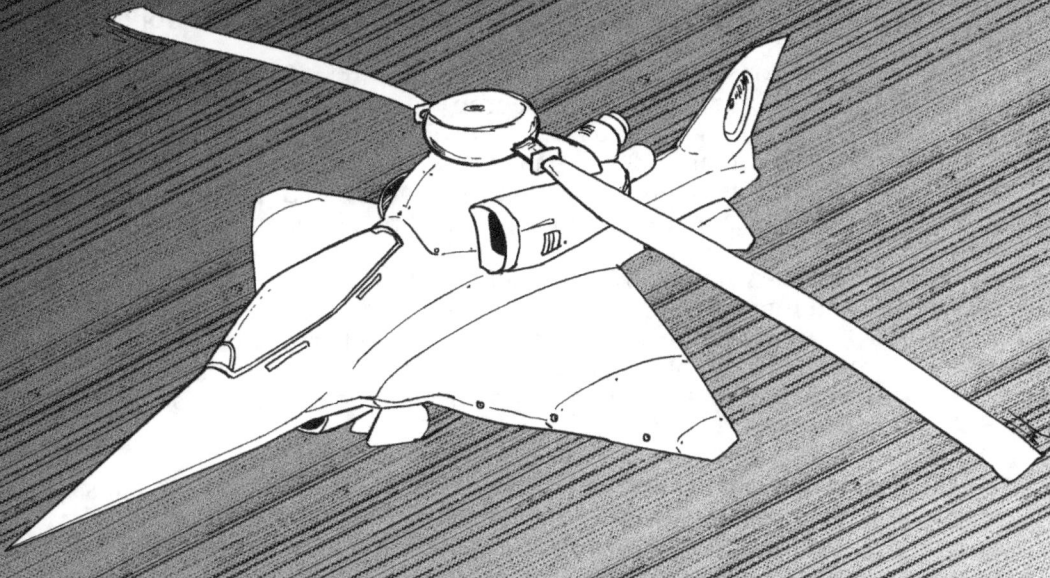

FLATBED SCANNER
- $$ -

Flatbed scanners have been around for decades and remain the professional standard for digitizing images drawn on paper to bring them into your digital workspace.

Unlike a smartphone or camera, a scanner provides an ultra-high-resolution scan that is free of distortion. Place your image(s) on the scanner and scan them. Copy the files to your computer; it's that easy.

Scanners have a wide variety of default and advanced scanning options. You can choose color, or black and white, and adjust the resolution. Scan to JPG, PDF or other file options and quickly save your work.

Most consumer-level scanners come with software and plug into any basic home computer or laptop with a USB cable. An affordable, entry-level Canon CanoScan or Epson scanner will get the job done and cost less than $100. The price goes up quickly for more professional, larger flatbed models. I would personally avoid the home printer with a built-in scanner - they are cheap and break instantly.

Scanners are like exercise equipment. People tend to buy them for a job and then put them away to collect dust for the rest of eternity. Search for used scanners online or at your local thrift store and Goodwill; you will probably find a bargain on a perfectly good late model scanner. Its software drivers can be found online by searching the scanner's model number.

If the quality of the scan is important to you, scanning drawings is a better solution than using a phone. You should always keep a good backup of your artwork to use in a portfolio. Therefore you should always scan your completed artwork with a good scanner!

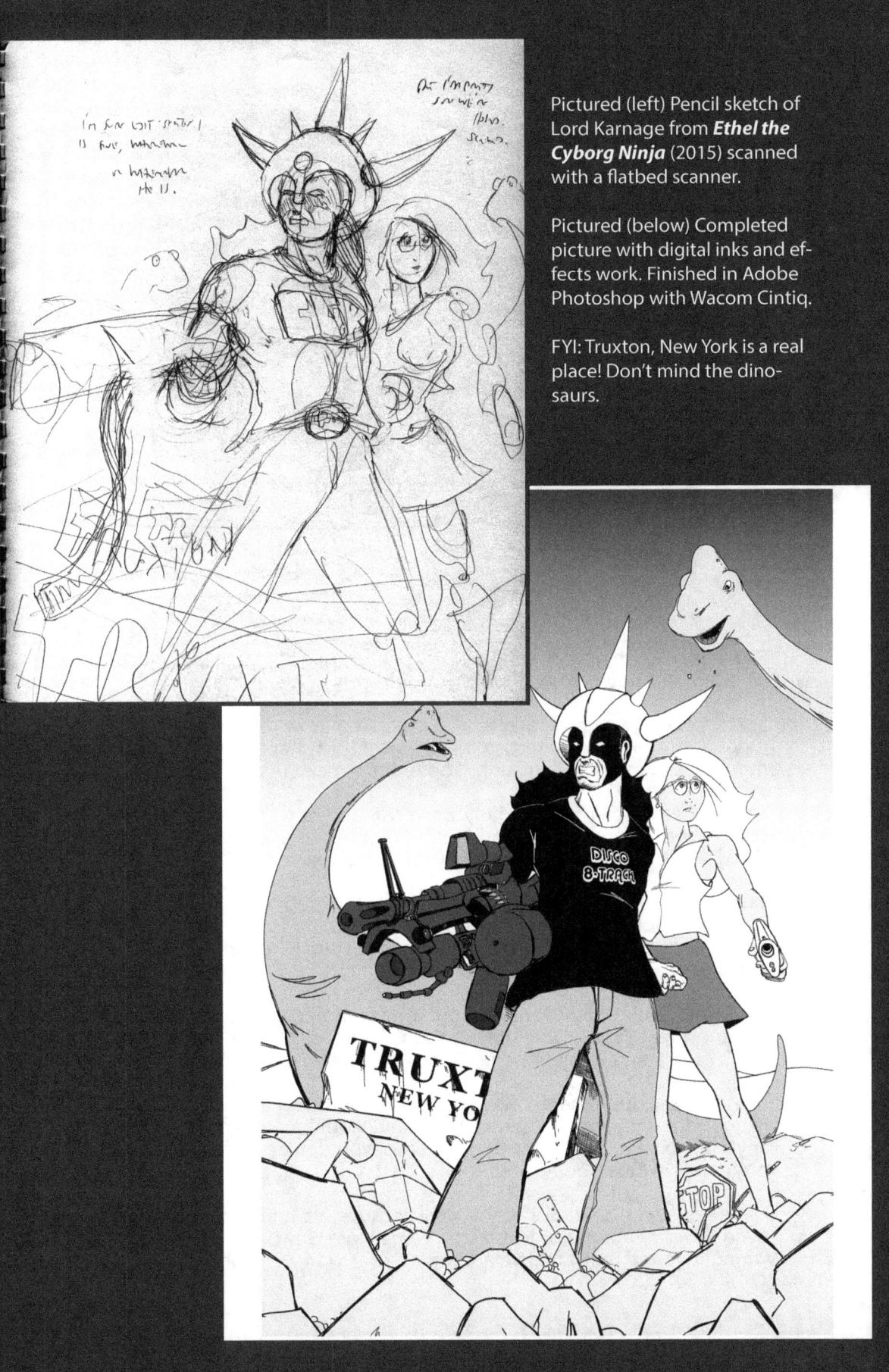

Pictured (left) Pencil sketch of Lord Karnage from **Ethel the Cyborg Ninja** (2015) scanned with a flatbed scanner.

Pictured (below) Completed picture with digital inks and effects work. Finished in Adobe Photoshop with Wacom Cintiq.

FYI: Truxton, New York is a real place! Don't mind the dinosaurs.

SMART TABLETS
- $$ -

Dear readers, we now abandon ye olde-timey pencil and paper and go all-digital. It's not as easy at looks, though, or is it? It's all relative.

Smart tablets (which I'll refer to as tablets from now on because sometimes they aren't very smart) come in a variety of shapes and sizes from numerous brands like Samsung, Apple, and Amazon.

The modern tablet is incredibly powerful and versatile. Tablets have touchscreens, cameras, and an infinite number of apps with which to draw, watch movies, post pictures, or play video games.

Tablets can range from $50 to well over $1000 depending on the size and brand; Some are better for drawing than others. In this section, I will cover the basics to point you in the right direction when shopping for a drawing-specific tablet.

All tablets require some form of input mechanism to draw on the screen. The most readily available drawing tool for a tablet is your finger, and that's great news. Fingers are free! They don't even require batteries.

You can use your finger to draw and trace objects on the screen, which is good for kids and anyone starting out. Additionally, you can draw anytime and anywhere by using the tip of your finger inside a drawing program like Kids Doodle and Adobe Sketch.

Finger drawing is awesome for kids because it's fun, and they don't need to worry about holding a pen. Fingers are way better art tools for younglings and their creative ambitions. Toes work well too.

You should buy a tablet to fit your budget, needs, and lifestyle. A basic, inexpensive Android tablet is suitable for all-purpose web browsing, shopping, and watching Netflix. A tablet like the Android-powered Samsung Galaxy Tab2 can be good for drawing depending on what it is you're trying to achieve and how particular you are about your input mechanism.

What do you mean by "how particular you are"?

Great question! I am accustomed to drawing with pencils and pens. There is no amount of training which is ever going to get me to draw on a cheap tablet with an entry-level drawing tool.

However, when you or your kids are starting to draw digitally on a tablet for the first time, then you will have a much higher tolerance when learning new drawing tools and methods. You can't teach an old dog new tricks. (I couldn't even teach my dog tricks when she was young.)

This section sounds techno-snobby, but it isn't, people become accustomed to their tools, especially us finicky and emotional artistic types. There is a big tactile difference between pencil on paper and pen on the screen.

Just because it's cheap doesn't mean it's bad. Entry level drawing tools on a tablet can be as good as the person using them. I have seen artists create masterpieces with their fingers on a phone.

If you're on tight a budget and have never drawn digitally before, consider a decent tablet with a good consumer-level pen. Before jumping into the high-end products, you should see if you even like to draw digitally. Better tools don't always bring better results.

Later on, if you or the kids become serious and want more power and control, then consider upgrading to a high-end tablet like an iPad Pro with the Apple Pencil (which is what I used to draw most of the pictures for this book.) A Kindle Fire from Amazon starts at less than $50. It's an option for starting out and a good choice for kids because it's cheap.

Android tablets are a reliable choice because they cost less than iPads and work sufficiently well at everything. Pen options are (as of this writing) limited on Android tablets, I'll cover that in the next section. I have a Samsung Galaxy Tab S2 (the white one pictured on the previous page) and travel with it often because it is a more convenient size than my iPad Pro 12.9" and costs far less.

In addition to general web browsing and apps, I use my Galaxy for storyboarding and sketching ideas; I never use it to finish projects. My kids have used it for drawing, and it will suffice. Autodesk SketchBook is free, and it is my recommended drawing app for Android.

The iPad Pro is in another league, and I'll cover that separately on page 29.

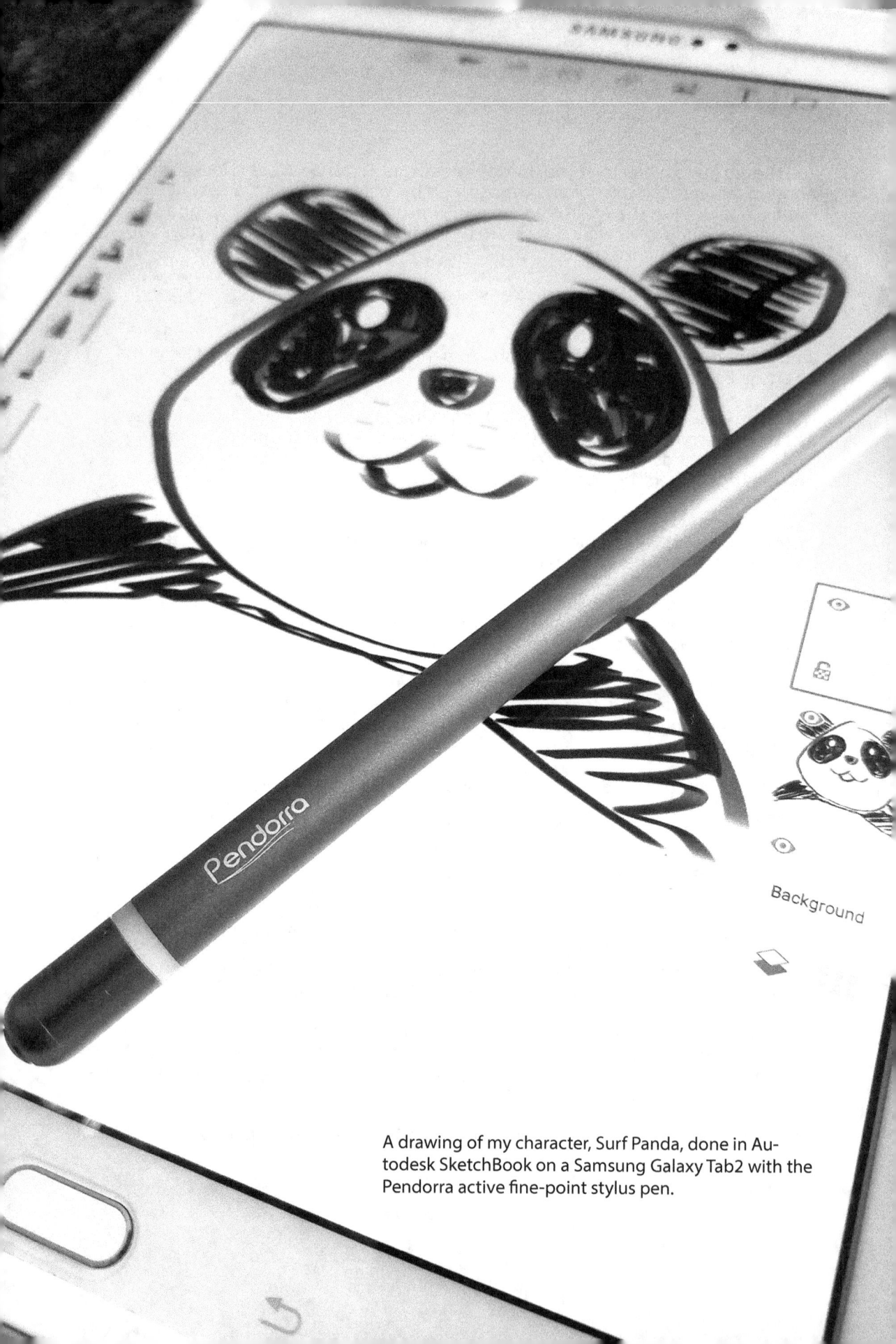

A drawing of my character, Surf Panda, done in Autodesk SketchBook on a Samsung Galaxy Tab2 with the Pendorra active fine-point stylus pen.

DIGITAL PENS
- $$ -

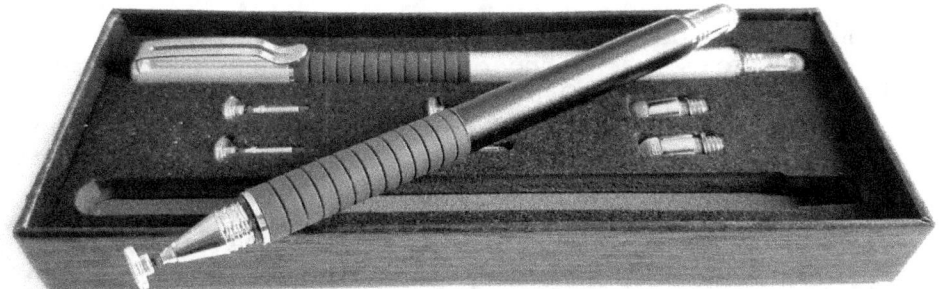

Just like the tablets and phones upon which they draw, digital pens come in all shapes, sizes, quality levels, and price points.

Pictured above is the Meko Universal Stylus, which comes with two pens and six replacement tips for less than $15 on Amazon! It works on all touch screens, Android, and iPad, phones and tablets.

Pens like the Meko use no batteries and require no Bluetooth connection because they are glorified fingers. For those on a budget who want to draw or take notes with a tool that feels like a pen, try one of these.

The Meko is interesting in that it has two kinds of tips. One side of the pen features a soft cushion that glides about the screen and draws lines with ease. The other side has a discus which gives more resistance and keeps the tip of the stylus on-screen while your hand changes the pen's angle. The see-through discus allows the user to see view the tip. Pens like the Meko have no pressure sensitivity and are very simple.

The Meko is a good pen set for beginners and kids; your children will have to work extra hard to scratch the screen with its cushioned surface. It is a good, manageable choice for doodling, sketching, note-taking, and storyboarding on the go.

Pictured on the previous page is the Pendorra "active fine point stylus pen" which is battery powered and works will all phones and tablets. It feels more substantial than the Meko but works more or less the same. Its fine point gives some resistance and feels good on screen, yet technically works no better than a finger or cushioned stylus.

Digital pens like those featured here are excellent starter tools. They don't cost much; they are versatile and convenient. They're easy to throw in your bag or purse and use when needed.

While good for doodling and teaching kids to draw, non-Bluetooth pens are difficult to use when trying to create finished, professional artwork because one cannot rest their hand on the screen while drawing. Touch screens are not smart enough to recognize two points of contact, and a resting hand acts as one point of contact while the tip of the pen acts like another.

This may not bother some people, but it bothers me and makes pens like this practically useless compared to a Bluetooth connected device like the Apple Pencil or Wacom pen for detailed drawings. Higher-end, more expensive pens are smart enough to recognize two points of contact and differentiate which one of them is the pen.

Some workarounds while drawing with entry-level pens, include placing a cloth beneath your drawing hand if you are a "hand rester" like me. Most tablets will not recognize the cloth as a point of contact, but it is a clumsy workaround, in my opinion (although an inexpensive one worth trying if starting out on a budget.) There are specialty gloves sold for this purpose, too, though I am dubious.

The Meko set is a terrific bargain and gets the job done, provided you have reasonable expectations. I have seen other pens on the market that resemble the Meko and sell at a similar price point on Amazon. The fit and finish of the Meko pens are good.

The Pendorra pen in this section costs twice as much as the Meko and has a nicer weight and feel with a smaller tip. It works particularly well with the iPad Pro, though not as good as the Apple Pencil. I don't notice much of a difference between the Pendorra and the Meko on my Samsung tablet.

Artists charge the Pendorra with any USB charger or a laptop, I don't understand what magic sorcery it uses to require charging, but it seems to work. The Pendorra pen is not pressure-sensitive (neither is the Meko, or your finger for that matter.)

Professionally, these budget pens are all terrible compared to the Apple Pencil or Wacom tools featured later in this book. However, they are more convenient because you can use them on any phone or tablet, and they're better for kids who break stuff.

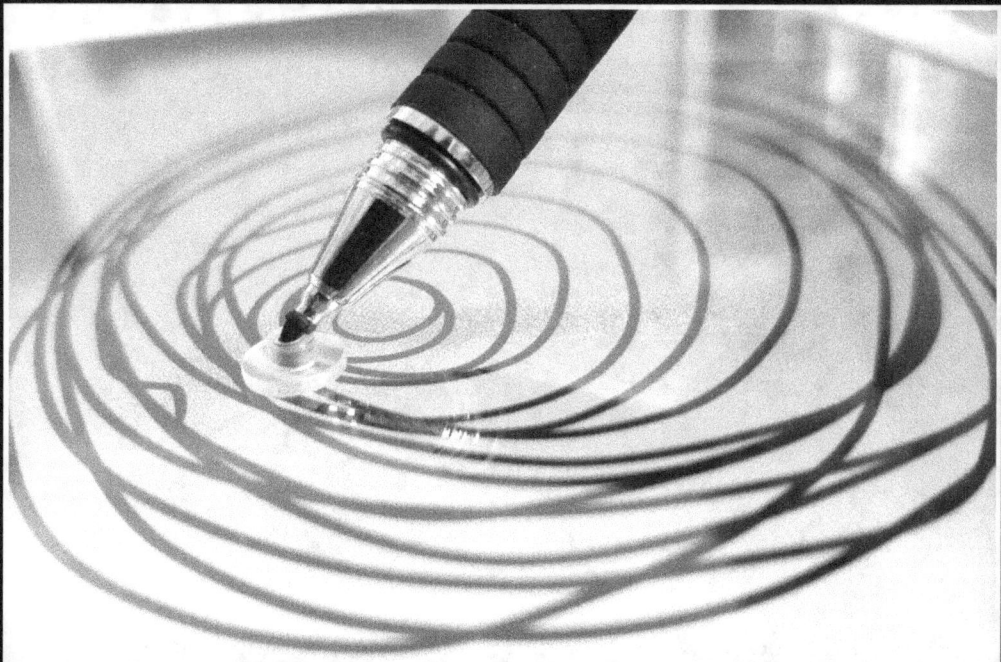
Meko pen on Android tablet drawing inside Autodesk SketchBook with the clear disc attachment.

Meko pen drawing inside SketchBook with the fiber tip.

GRAPHIC TABLETS
- $$ -

"Graphic tablets" have been around a lot longer than smart tablets like the iPad. I first saw a Wacom tablet back in the 1990s and thought it was a monstrous abomination that was impossible to draw on. Thankfully, they are much better now!

Unlike a smart tablet, a graphic tablet does not have a screen; Think of it as a smart tablet without the screen. A graphic tablet requires an additional monitor to work. It provides a direct, pen-like interface for Adobe Photoshop, Illustrator, Corel Draw, Clip Studio, Autocad, and other high-end graphics programs.

Imagine using a mouse, but instead of a mouse, you are moving the pointer with a pen with your eyes focused on the computer screen (not the tablet.) Graphic tablets usually bring the added benefits of pressure sensitivity and tilt functionality that can affect your brush strokes.

The advantage of using a graphic tablet is that it works with your computer or laptop via a USB cable and costs less than one of the giant Cintiq-style screens with a built in monitor. Graphic tablets are also very portable. The pen is wireless and can be equipped with a variety of tips, or "nibs" as Wacom calls them.

The disadvantage of using a graphic tablet is that the artist is not looking at what they are drawing beneath their pen, they are watching the lines form on the external monitor. These tablets require practice to use.

Most graphic tablets are not prohibitively expensive, and they are easy to install and use. Brands like Wacom have been making tablets for years. Chinese companies like Huion have appeared more recently and offer budget-priced alternatives.

If you can wrap your brain around drawing while looking at an external monitor, then graphic tablets are a good option for you. Modern tablets are small, portable, and they work well with laptops. Graphic tablets are an affordable and precise way to use big-name software like Photoshop on a Mac or PC with pressure-sensitive pens.

When you create drawings or elaborate comic book pages with dozens of layers, multiple fonts, shading, colors, and more, then you'll want to work on a computer rather than an iPad or lesser smart tablet.

Personally, I have never been able to draw on a graphic tablet. My feeble and easily confused brain cannot take the disconnect between drawing on a surface while looking at an external screen. However, you should not rule it out. Find a friend or store that has one and try it out.

I have drawn on a Wacom Intuos, which is one of their budget-priced models. For less than $100 you get a tablet and an excellent Wacom pressure-sensitive pen and some starter software. The pressure sensitivity is a cool feature that allows you to draw thin or thick lines depending on how hard you press down; this feature is ideal for making natural-looking lines.

Wacom will be happy to sell you a variety of nibs that alter the feel of the pen on the surface. I use a rubber nib. Other options are plastic, felt and spring-loaded. Additionally, Wacom offers many other graphic tablets at different price points with enhanced features.

Pictured below is a (silly) drawing of my Wacom pen and collection of nibs contained secretly within the pen holder. I use my pen on a Wacom Cintiq, which I will cover on page 30. The Wacom-brand pens are more or less the same regardless what model tablet you own.

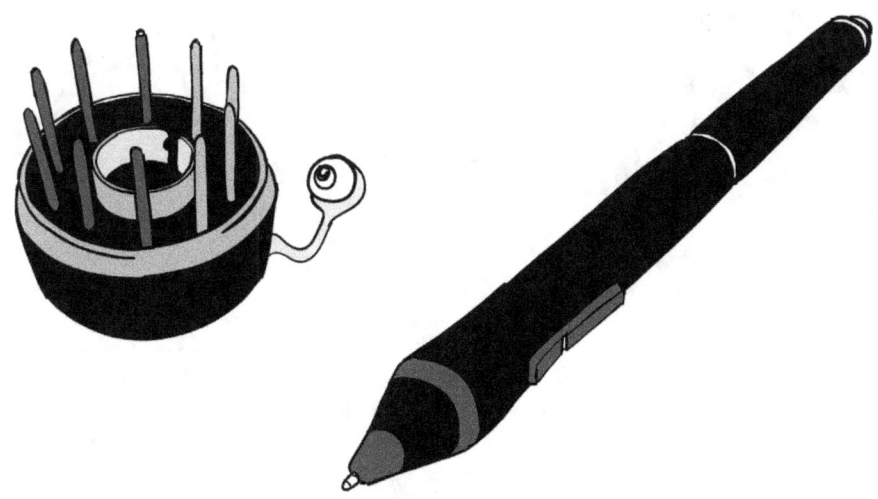

Page from ***Retromegatrex: The Lost Art of Mark Bussler 1995-2017*** featuring my characters Haylee Davenworth, Sally, Ethel the Cyborg Ninja and Space Tentacle Eyeball Monster. Sketched in Adobe Sketch on iPad Pro, finished in Adobe Photoshop on Wacom Cintiq.

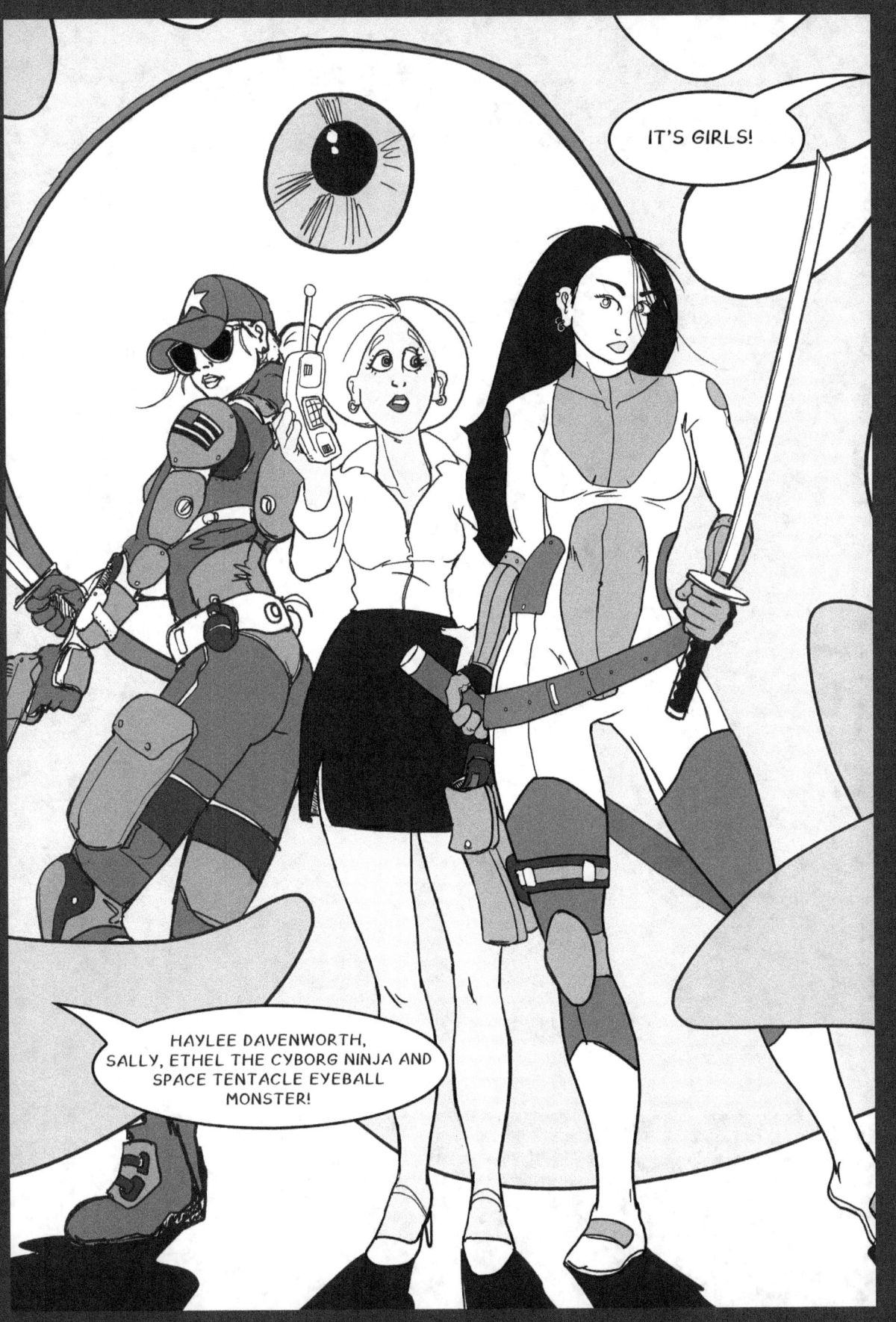

iPAD PRO
- $$$ -

There are smart tablets, and then there's the iPad Pro. It earns its own section in this book because, when combined with the Apple Pencil, it is the best tablet for drawing that you can buy. This drawing superiority comes with a high price tag, of course (everything from Apple does.)

Compared to "less smart" tablets, the iPad Pro works better, feels more substantial, and has the best digital pen on the market; they call it the Apple Pencil, but I call it a pen.

The Apple Pencil is a pressure-sensitive pen that sells for roughly $100 and connects to the iPad with Bluetooth for seamless, nearly lag-free operation. It is pressure-sensitive like the Wacom pen and tilts so that you can give organic brush strokes by holding the pen at different angles. The pen is charged by plugging it into the iPad, or using the iPad charger overnight; it holds a charge for several hours.

The iPad Pro is available in a few sizes with varying degrees of drive space that affect its price. I use the big one, the 12.9" model (pictured on the previous page.) It's huge, far too large to throw in a pocket or bag for daily web browsing, but perfect for drawing on the go (It's also great for watching movies and reading comic books.)

Prices fluctuate, and Apple releases new models constantly, so I will refrain from listing a price, but know that it is not cheap. When it comes to the iPad Pro, you get what you pay for.

What I like most about the iPad Pro are convenience and performance. It is ideal for sketching, storyboarding, and character creation. I can create wherever I am, whenever I want to; on the couch, in bed, on the patio, on a trip, waiting for the kids to get done with practice. (As of this book's 2019 revision, I use the iPad Pro and ProCreate to complete finished pieces of comic book artwork. It's that good.)

The Apple Pencil is snappy and works incredibly well with Adobe Sketch and ProCreate, my go-to software packages for drawing. I draw when I can, save my files to Adobe Creative Cloud and then open them on my Mac for finishing work inside of Photoshop. The iPad Pro is worth its weight in gold.

The Windows Surface Pro is the only other pseudo-tablet with a pen that even comes close to iPad Pro. It also functions as a laptop. I'll stick with my iPad, thank you.

2019 revision note: As of this writing, most of the less-expensive "non-pro" iPad models now include Apple Pen support. There is also a new Apple Pencil 2.

Additionally, companies like Dell and HP produce touch-screen laptops, but from what I've seen, the iPad still rules them all.

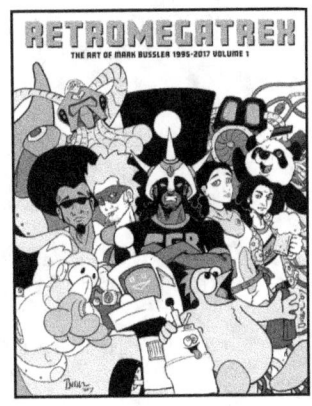

WACOM CINTIQ
- $$$$ -

The ultimate digital drawing force in the universe takes the form of a Wacom Cintiq, a massive graphic tablet combined with a monitor that works with your Mac or PC.

Unlike traditional graphic tablets that connect to a computer without a screen, this Wacom is a screen. Think of it as a giant iPad that works with Wacom-brand pens and your computer. Wacom sells the Cintiq in several sizes and it offers the most comprehensive "full-featured" drawing experience possible.

The Wacom Cintiq is also the most expensive thing in this book. Professionals around the world use the Cintiq for the best digital drawing performance with the best software. You'll love drawing on the screen like a giant piece of digital paper. It is incredible, but is it better than iPad?

The biggest difference between the Cintiq and an iPad Pro is the computer and software that drive it. When you hook up the Cintiq to a Mac Pro or high-end PC, you'll fly through full-size, 600dpi high resolution drawing files with more than 100 layers and never notice any slowdown. Additionally, I find the Wacom better for completing jobs like cover designs, advertising, and finished pieces of print work (I actually prefer the iPad Pro for straight-up drawing with ProCreate.)

Unlike the iPad, the Cintiq is not portable. Mine is the 22" option; there are larger (and smaller) ones available like a 27" model, which is like the Death Star of digital drawing. I think they have even bigger ones as of 2019.

There are less expensive Cintiq-like products out there, but the pros use a Wacom. At this level of performance, you want the best. I use the Cintiq for all of my comic books and guidebook layouts. It is worth the investment if you're using a lot of different software packages for professional work. Not for kids.

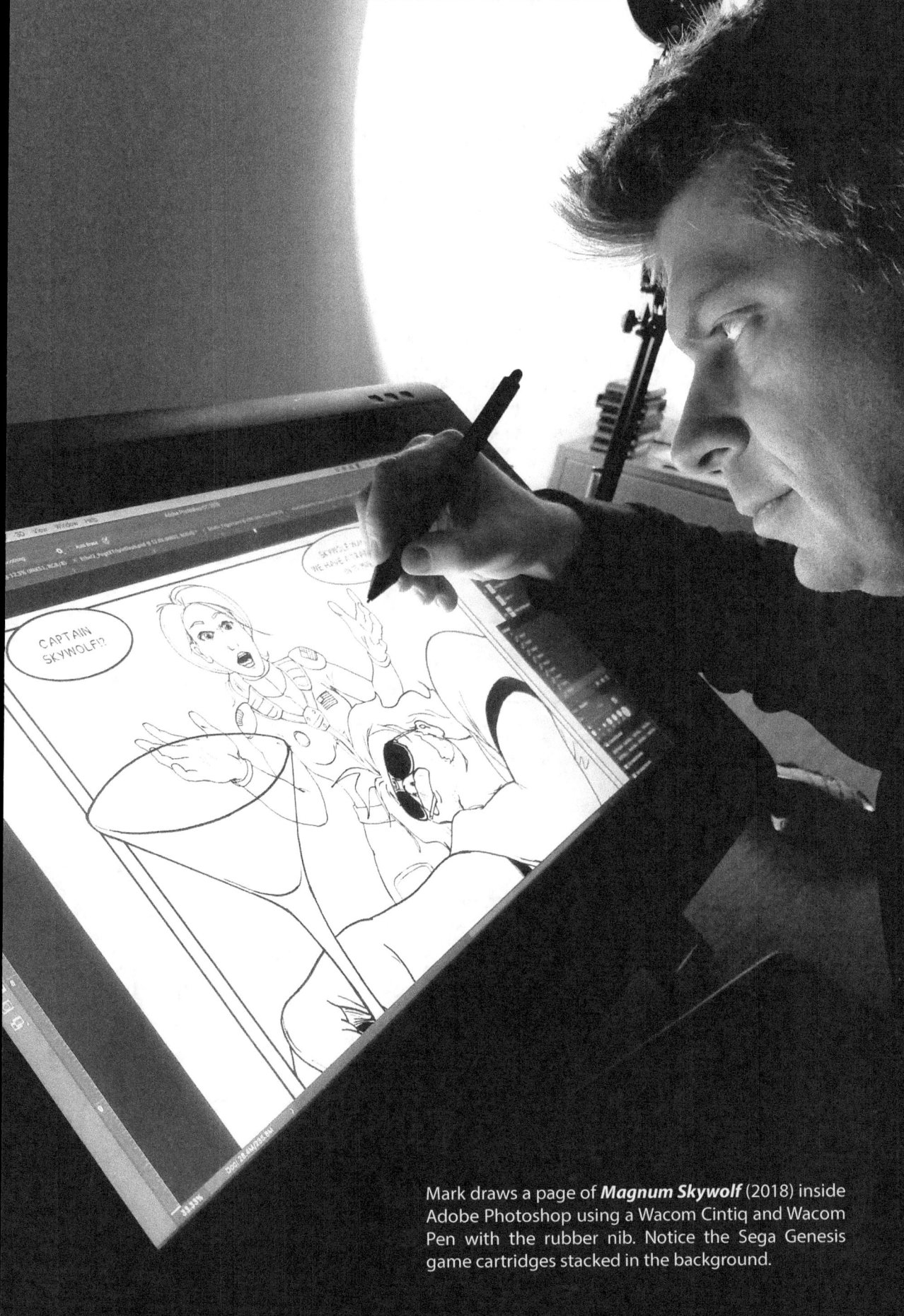

Mark draws a page of **Magnum Skywolf** (2018) inside Adobe Photoshop using a Wacom Cintiq and Wacom Pen with the rubber nib. Notice the Sega Genesis game cartridges stacked in the background.

Pictured is a storyboard page for my book, ***Gleaming the Event Horizon*** (2018), drawn with the free version of Adobe Draw on iPad Pro with Apple Pencil.

CHAPTER 3: SOFTWARE

Your end goals and budget will largely determine what kind of art software you use. Are you looking to draw for fun, or are you planning to earn money from your work?

As artists, all that we need is a pencil and paper to create fabulous images (or at least mediocre ones.) When drawing digitally, you will need a drawing program to work with your input mechanism and techno-drawing-device. That sounds very technical!

When starting out, teaching your kids to draw or making art for fun, I recommend drawing with free software. Numerous affordable software programs and apps work well; many don't cost anything. I'll cover some of the best free programs on the next page.

If you are trying to draw and create professionally, then you need to buy the best software for the job that gives you pro results because you're competing against other people using high-end software and tools. There's a wide variety of specialized software packages for every art and design niche; I'll cover some of the largest and most popular ones in this section for drawing.

I created the silly picture above with my smartphone and Adobe Photoshop. I took a picture of a 5 1/4" floppy disk and used it as a model, traced over it, and added greyscale and comic effects. What kind of monster is lurking behind my floppy disc?

FREE DRAWING APPS
- $ -

For those of you looking to share the joys of digital drawing with your young children, I recommend free software that is fun and easy to use. You probably don't want to put a 3-year-old in front of Adobe Photoshop on the PC.

Kids absorb technology like a sponge and quickly learn to use anything on a touchscreen. Drawing on a tablet is intuitive and easy for children to pick up, they can learn by drawing with their fingers (no pens required!) Free software is more than enough to get started, though free software is often plagued with annoying advertisements.

The Apple app store and Google Play store are oversaturated and filled with junk. Type "drawing for kids" into the search bar and numerous colorful, free options will appear. My recommendation is to download whatever looks good and has the best ratings; the selection seems to change every week. Delete it if you don't like it.

Many free drawing programs have "in-app" purchases, make sure to disable them or lockdown purchases in the app store with a password.

All drawing programs have a variety of tools, brushes, and colors to play with, but I think you'll find that most of the free apps aimed at children are not well made. They are usually poorly designed and cheap, which is why I would skip all of them and go straight to Adobe Sketch (which is also free!) Autodesk SketchBook is another good free choice, though it is aimed at adults. I'll write more about Sketch and SkechBook on the following pages.

Free software for grown-ups still has plenty of colorful brushes and painting tools with less obnoxious, intentionally juvenile interfaces. Additionally, apps from big companies like Adobe and AutoDesk don't need advertisements because they make their money by selling full versions of their professional, high-end software subscriptions.

The best children's drawing program that I have used is Kids Doodle, which is a neat drawing app that adds sparkler-effects and neon colors to your drawings. It also records motion, which is fun. It has ads but works better than expected, better than most of the junky free apps.

I drew the bottom right picture on the next page with Kids Doodle. The original drawing is bright and colorful (which makes my dog look even crazier than she is.)

The built-in, default iPad photo app even comes with a drawing tool. Take a photo and select "edit," then choose the icon that looks like three little dots and select markup; some basic pen and brush options pop up to provide hours of "drawing antenna ears on the dog" entertainment.

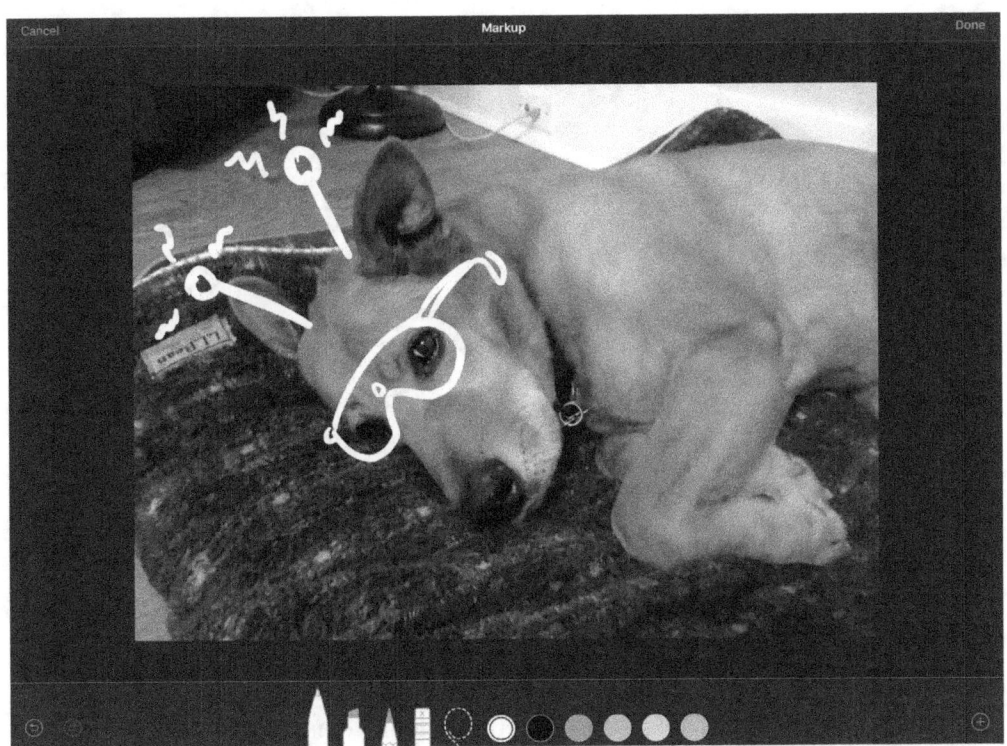

My dog, Stella, enthusiastically modeling for a photograph that was touched up with the markup tools inside the default iPad camera app.

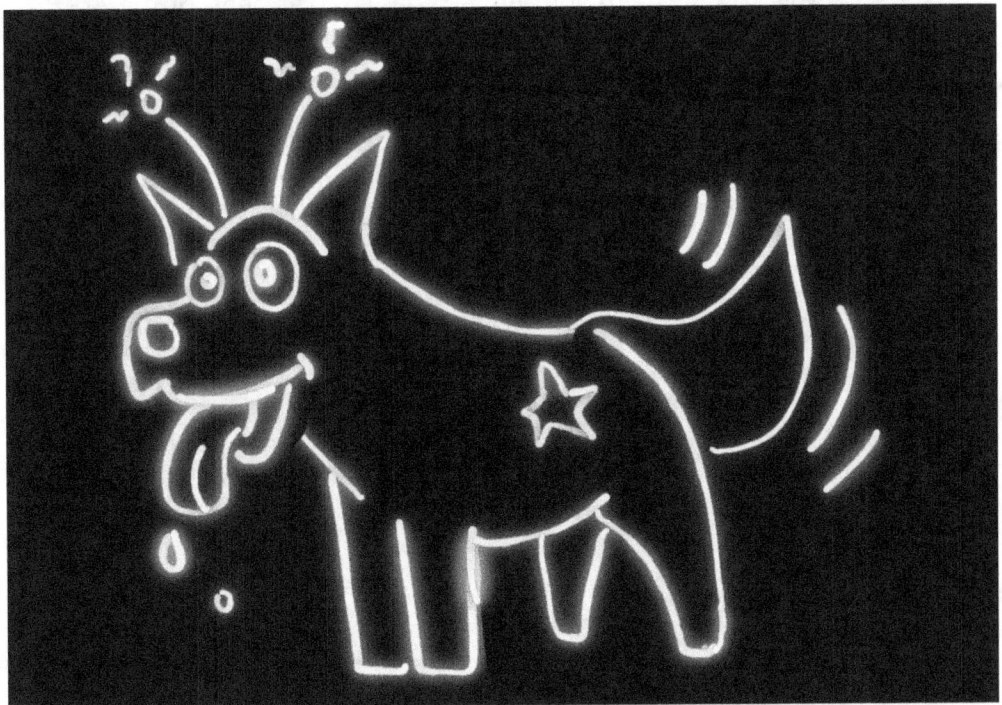

Stella drawn with Kids Doodle. Notice the accurate drool, antennae, and tail wagging. I added the star for effect.

Those with pre-teens or teenagers getting serious into art, or those looking to get more professional with their own drawings have plenty of free options to choose from that offer more power and greater performance than Kids Doodle (though Kids Doodle is growing on me.)

The best free tablet-based drawing software that I have used comes from the biggest companies in the industry, such as Adobe and Autodesk. Adobe Sketch and Autodesk SketchBook are scaled-down, free versions of their bigger pro-grade drawing software. They are ideal for young artists-in-training on any budget at any skill level.

The menu and interface in Adobe Sketch are very similar to those in Adobe Photoshop. Therefore someone who learns Sketch will have an easier time learning Photoshop later on. The same goes for Illustrator and Sketchbook.

These tools have multiple-layer options and allow artists to zoom in and draw closely (as seen in the picture on the next page). Sketch, Sketchbook, and Draw all have the useful "undo" feature and a myriad array of adjustable tools and drawing implements like pens, brushes, markers, and pencils.

You'll be able to draw with your fingers, basic tablet pens, or the Apple Pencil (seen on the next page.) Artists can take pictures with their tablets and bring the photos directly into these drawing programs for tracing, inspiration or effects.

I drew most of the drawings in this book with Adobe Sketch and Adobe Draw! They are free and produce print-quality images; I'll explain the differences between Sketch and Draw in the following sections.

You can draw and publish webcomics straight out of Adobe Sketch, Adobe Draw, and AutoDesk SketchBook without having to bounce anything off Photoshop or a laptop. Free doesn't mean cheap or bad. In this case, free means that you have more money to spend on a better tablet, computer, or superior drawing pen.

Later on, if you or your kids get more serious and head towards real print-work or art school, you'll have an easier time understanding the more complex workflow in Adobe Photoshop and other Adobe software like Illustrator.

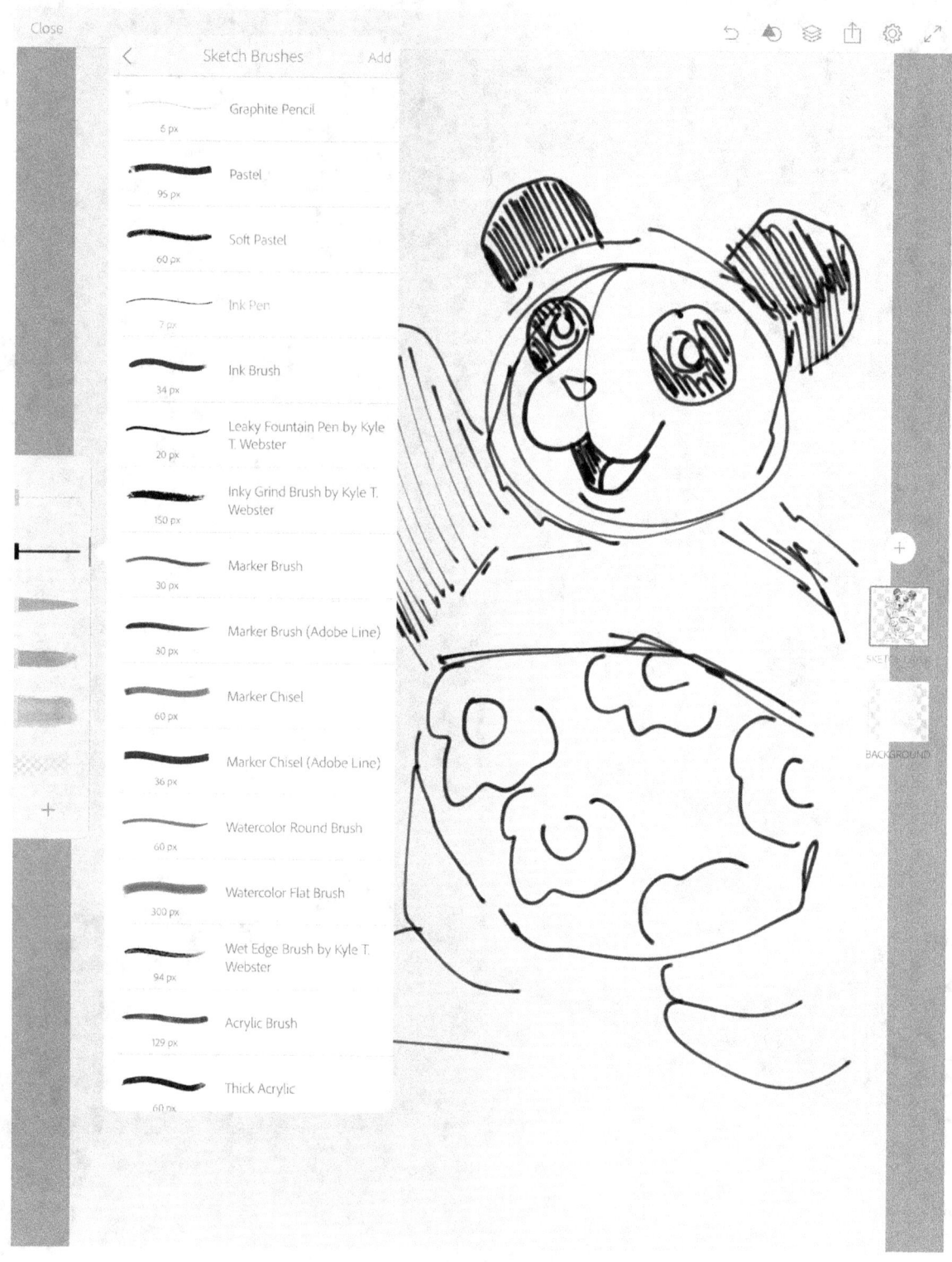

(This page:) My character, Surf Panda, sketched in Adobe Sketch.
(next page) Two more loose sketches of Surf Panda from Adobe Sketch on iPad.

ADOBE SKETCH AND ADOBE DRAW
- $ -

Kids who start out using Adobe Sketch and Adobe Draw will eventually graduate to Adobe Photoshop and the Adobe Creative Suite line of paid products. Think of Adobe Sketch and Adobe Draw as Photoshop with training wheels.

As of this writing, Adobe distributes two drawing programs (that are somewhat similar) called Adobe Draw and Adobe Sketch. Sketch is better for loose sketching. Draw is better for creating finished pieces. Both are free. You can also download the Adobe apps for your Mac or PC if you chose to draw with a graphic tablet.

These programs are both super-fast and responsive, and they allow for fast movements and brisk pencil strokes with no lag (on a good tablet.) Adobe's menu and tool interface is intuitive and works well on all devices. Sometimes, I use Sketch for comic book page layouts, storyboards, and quick, rough drawings. It offers a good variety of pen, pencil and brush options that the user selects from its menu.

Adobe Sketch and Adobe Draw allow artists to draw in layers, a convenient feature that has been a big part of Photoshop since the beginning. I make a rough sketch on one layer, add a layer for another more detailed sketch, and more layers as needed, and so on. You can also drop photos onto dedicated layers and later remove them.

Artists can save their work, print, and post online with Sketch and Draw. With just a few clicks, sketches from these apps can be saved to Adobe Creative Cloud, opened in Photoshop, ProCreate, Illustrator, or even Premiere Pro. Did I mention that they're free?

AUTODESK SKETCHBOOK
- $ -

Like Adobe, AutoDesk is a major company in the design, drawing, and engineering industry with a wide range of expensive professional software products. SketchBook is their entry-level free drawing program that does exactly what its title suggests that it should do.

I think that SketchBook is a worthy alternative Adobe Sketch (They are both free, so you may as well experiment.) SketchBook features a variety of pencil, pen, and brushstroke options as well as three-layer support. The brush strokes are snappy and responsive.

As of this writing, users can unlock a full version of SketchBook called Pro for a whopping $0.99 that gives more layers and better tools (according to their advertisement animations. These prices change so don't quote me on that.) Like any of the free drawing apps that I have covered in this book, I recommend SketchBook for beginner artists because it is capable and free. It works on Apple iOS devices and Android. Users can draw in SketchBook with their fingers or pens.

Save and share your creations directly from SketchBook to social media or your drive. As pictured on the previous page (and below), the menus and layer functionality are well laid-out and intuitive.

I drew the drawings for this section using the free version of SketchBook on iPad Pro with my Apple Pencil, which allows me to press harder for thicker lines when using the fountain pen tool. SketchBook is ok, but personally, I prefer Adobe products and ProCreate.

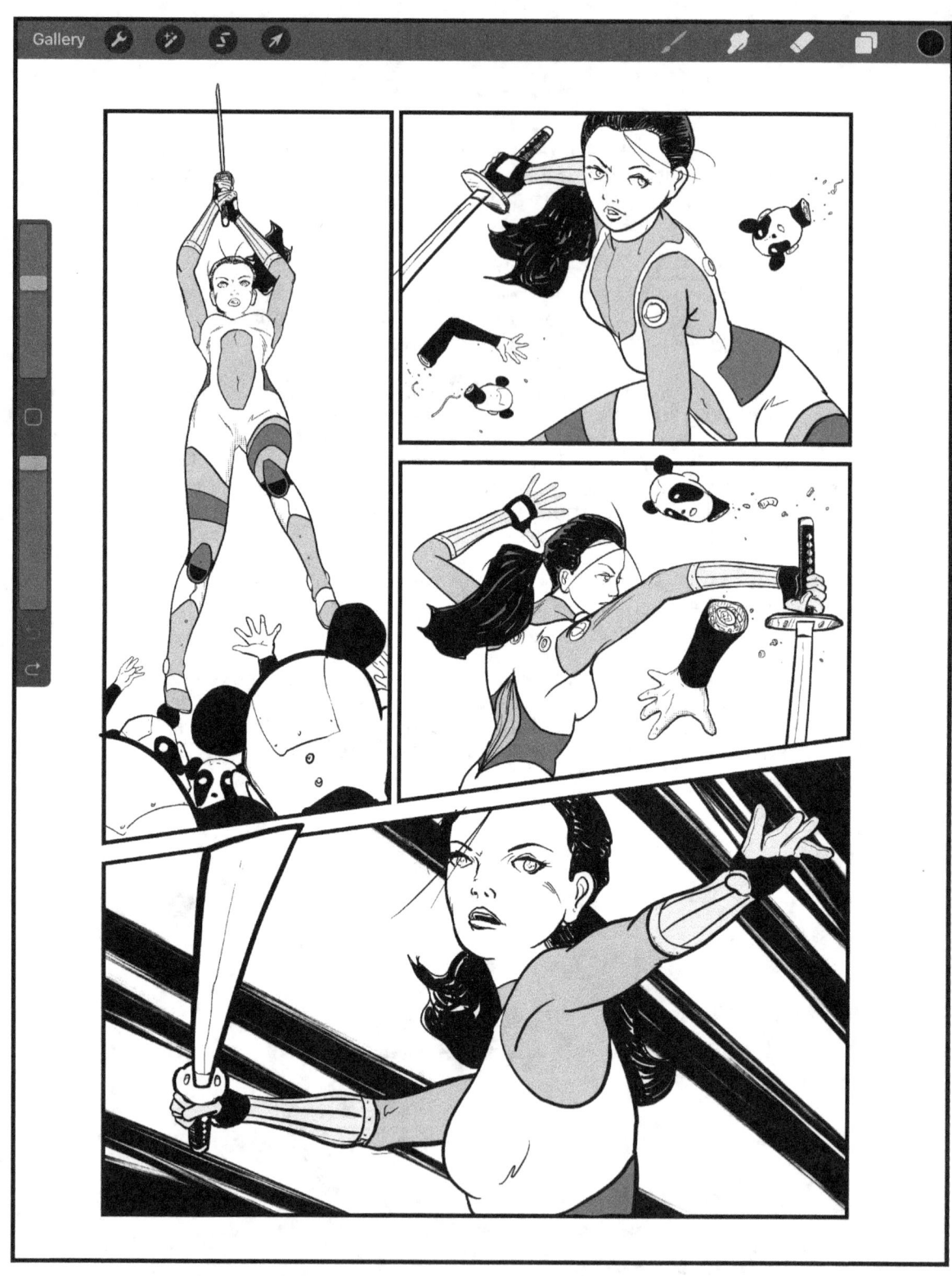

A complete "pre-dialog" page of **Ethel the Cyborg Ninja 2** drawn in ProCreate.

PROCREATE
- $$ -

I first wrote How To Draw Digital in 2018 before discovering the magical drawing program called ProCreate. I now ProCreate daily and revised this book in 2019 to include ProCreate because you need to hear about it.

From out of nowhere, it seems, ProCreate changed the entire digital drawing industry and my professional workflow. This New Zealand-designed software package works on iPad and costs as much as a few cups of coffee ($10 as of this writing.) Bang for the buck, you will find no better drawing software package than ProCreate, it crushes everything else with ease.

ProCreate manages to out-perform Adobe Photoshop for drawing comics and product designs because it focuses solely on drawing and painting. Additionally, ProCreate flies on the iPad because the developers designed it for the iPad.

Create a project, and start drawing, allow ProCreate to take your mind and creativity where it needs to go. The menus and workflow and intuitive and the performance spectacular. Everything is logically engineered for the iPad touch screen and works without the need for a keyboard or mouse.

Choose from any number of brushes and drawing and/or painting styles, the look and feel of ProCreate's default brush, pen, and pencil tools are similar to what one might find in Photoshop or Clip Studio, but better. Artists can easily adjust the brushes and strokes to fit their drawing style.

ProCreate allows creators to build projects in layers, just like Photoshop (but those who are familiar with Photoshop will have to un-learn a bunch of things and think in a slightly different - albeit more common-sense way.)

For $10, you can create high-def, full-size, ready-to-print comic book and manga pages, printable artwork, clothing designs and more. The developers at Adobe must be pulling their hair out trying to compete with this thing because it lays Adobe Sketch to waste (and Adobe Sketch isn't too bad!)

Additionally, where ProCreate really shines is in its customization and downloadable brush packages. Do an Internet search for "best ProCreate brushes," and you'll find some good recommendations, most of which cost a few dollars. I use a combination of default and specialty brushes for all of my projects these days.

I love ProCreate because it works as well as Photoshop, in some cases better, and is completely portable on the iPad. I can draw anytime, anywhere, and then save my drawings in .PSD format to Adobe Creative Cloud, where I finish them in Photoshop and Adobe Indesign for print. ProCreate also records your drawing strokes so that artists can export them as videos for social media posting and marketing.

CLIP STUDIO PAINT PRO
- $$$ -

The dark horse of digital drawing programs is Clip Studio Paint which is professional grade, manga-creation software previously known as Manga Studio. Why they chose to call it Clip Studio is beyond me; it's a terrible name with confusing packaging that fails to describe the power and performance of this amazing product.

Clip Studio has been used for years in Japan by manga artists. Originally developed by Celsys, it is dedicated manga and comic book creation software that is ideal for those of us drawing, illustrating, and writing comics. No matter what kind of comics you create, Clip Studio packs features well beyond its consumer-level price point.

For less than $100 on Amazon, you can order this fantastic program that will do much of what Adobe Photoshop can with respect to digital drawing, provided you have the patience to learn it. It does not have Photoshop's handy help feature or photo-editing capabilities, but it does have built-in 3-D modeling tools, manga effects, page layouts, background motions, and manga-style shading tools!

Don't let the fact that Clip Studio is sold on CD-ROM fool you. This stuff is great, though I had to hunt down my USB CD-ROM drive to install it. Is it still 1996? Thankfully updates are downloaded and not sold on 5 1/4" floppies. (you can also download the software from the company's website.)

I use Clip Studio Pro EX in my comic book and manga creation workflow. Occasionally, I make full page layouts with it and often used its 3-D modeling tools. I recommend that people stick with the tools and workflow that they're used to, but Clip is worth a look. If you want to draw professional comic books on a Mac or PC, but don't want to spend on Photoshop, buy Clip Studio Paint (or whatever they call it now, they keep changing the name!)

Clip is fairly counter-intuitive. I suggest that new users read or watch tutorials, the layout and instructions can be confusing and illogical. Clip has a wealth of drawing, coloring, and modeling functions.

This software has page templates, downloadable models, effects, and pretty much everything else imaginable for creating professional-quality books. It takes time to learn, but Clip Studio Paint is worth it.

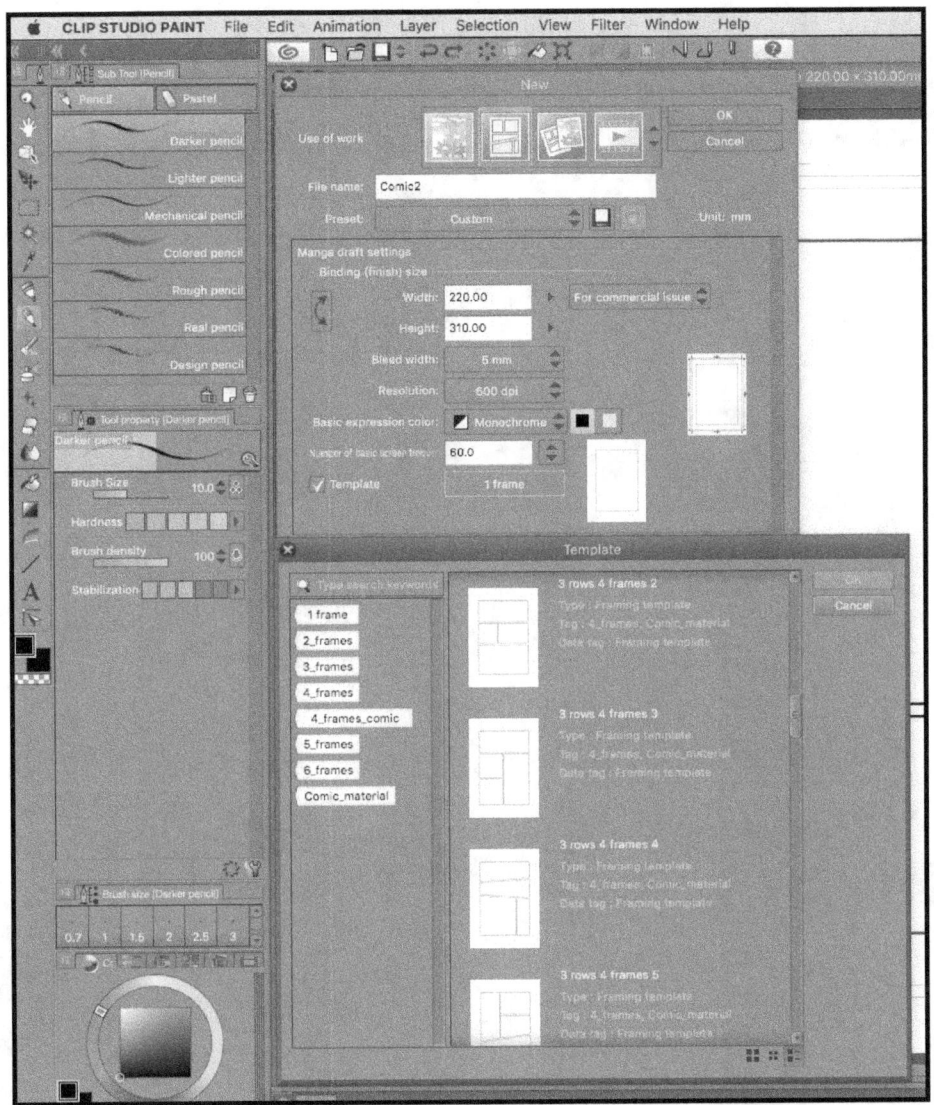

Clip Studio Paint Pro requires a powerful Mac or PC to run, especially when working in multiple layers with the 3-D modeling tools.

Pictured above are page layout templates. When creating a book, artists can specify the page size and resolution. Clip offers a wide variety of standardized manga-style templates to choose from. You can draw in each frame independently and export print-ready files. This is just the tip of the iceberg when creating in Clip!

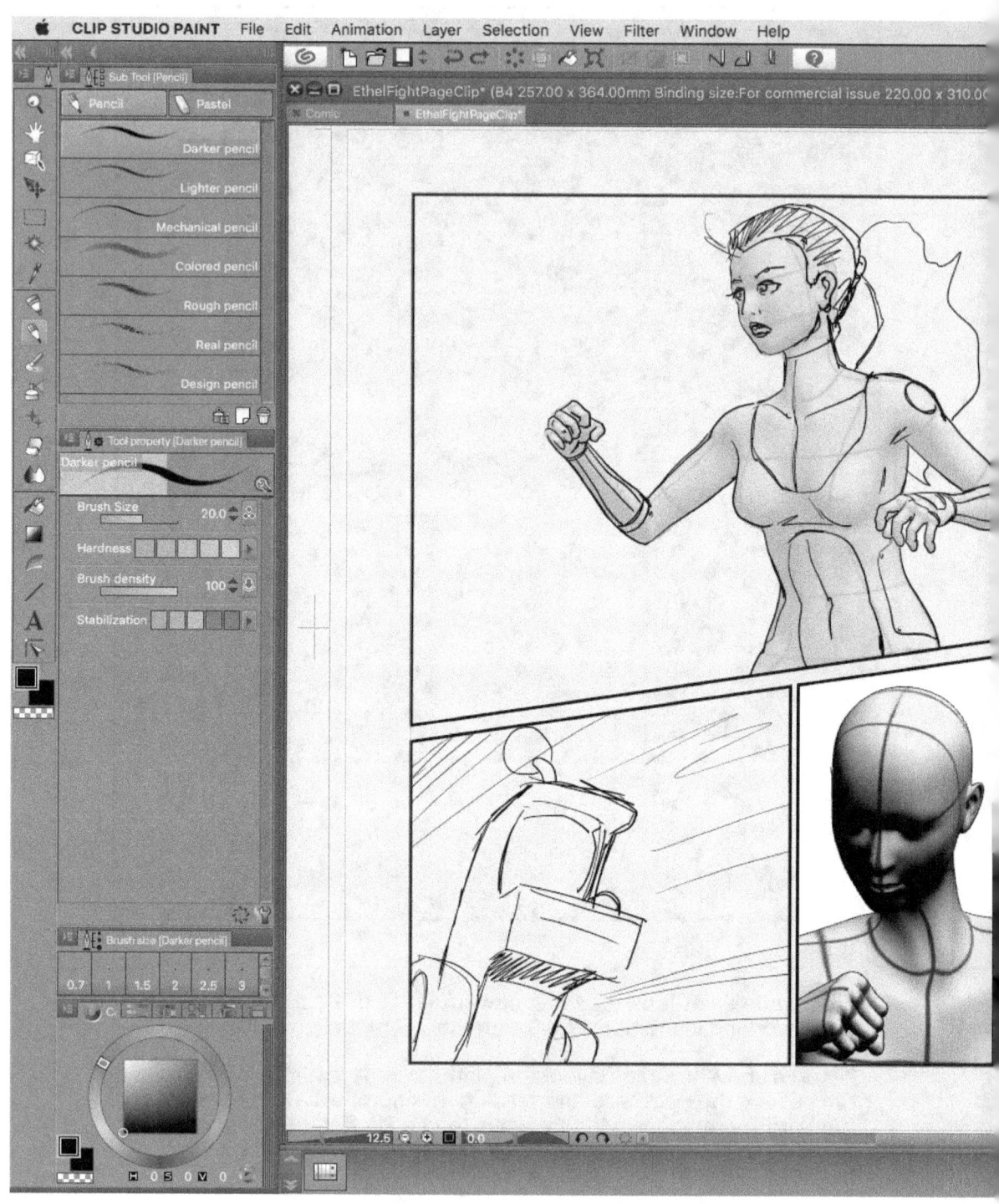

I used Clip Studio Paint Pro for modeling, page layouts, and sketching fight scenes in my book **Ethel the Cyborg Ninja 2**.

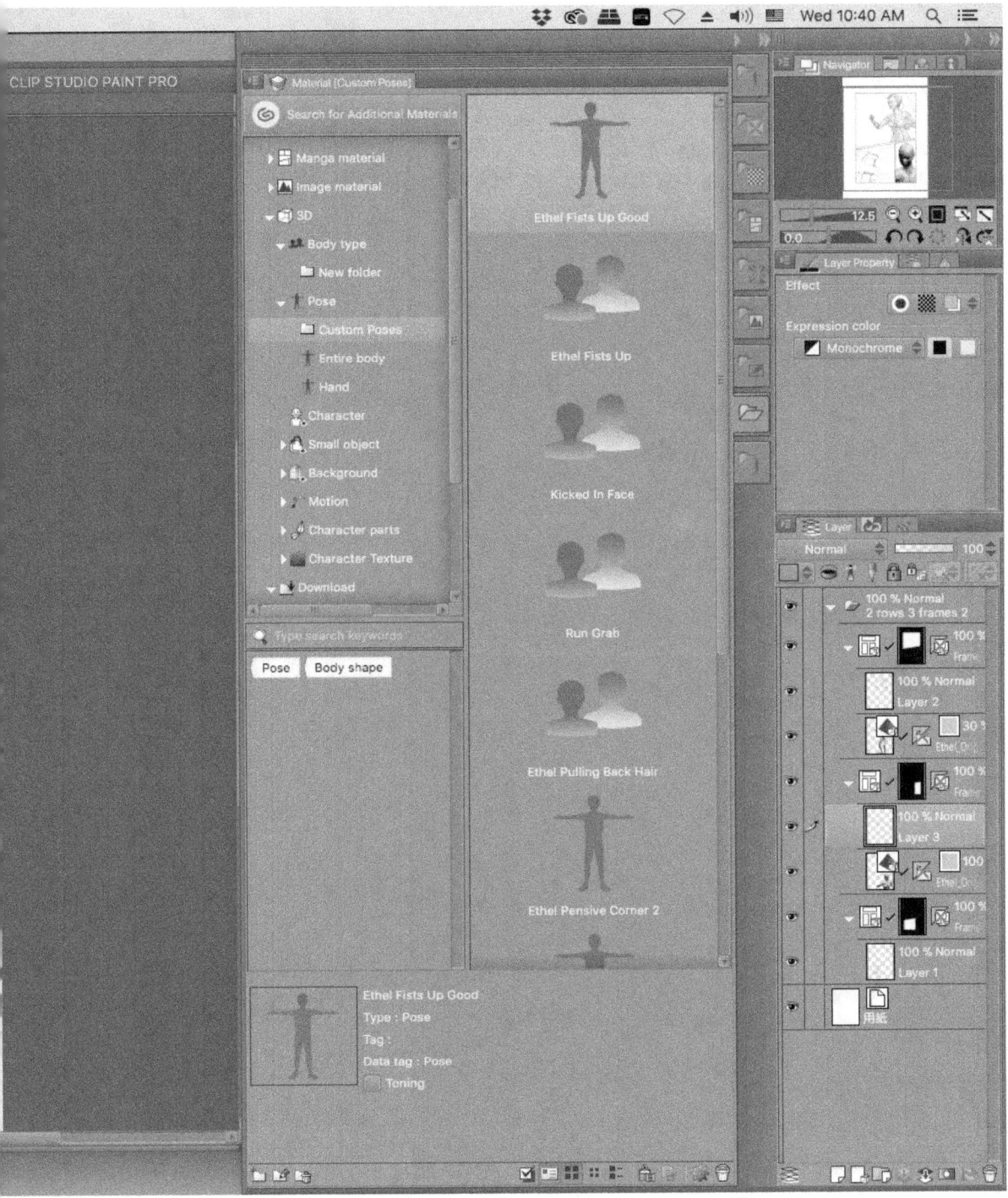

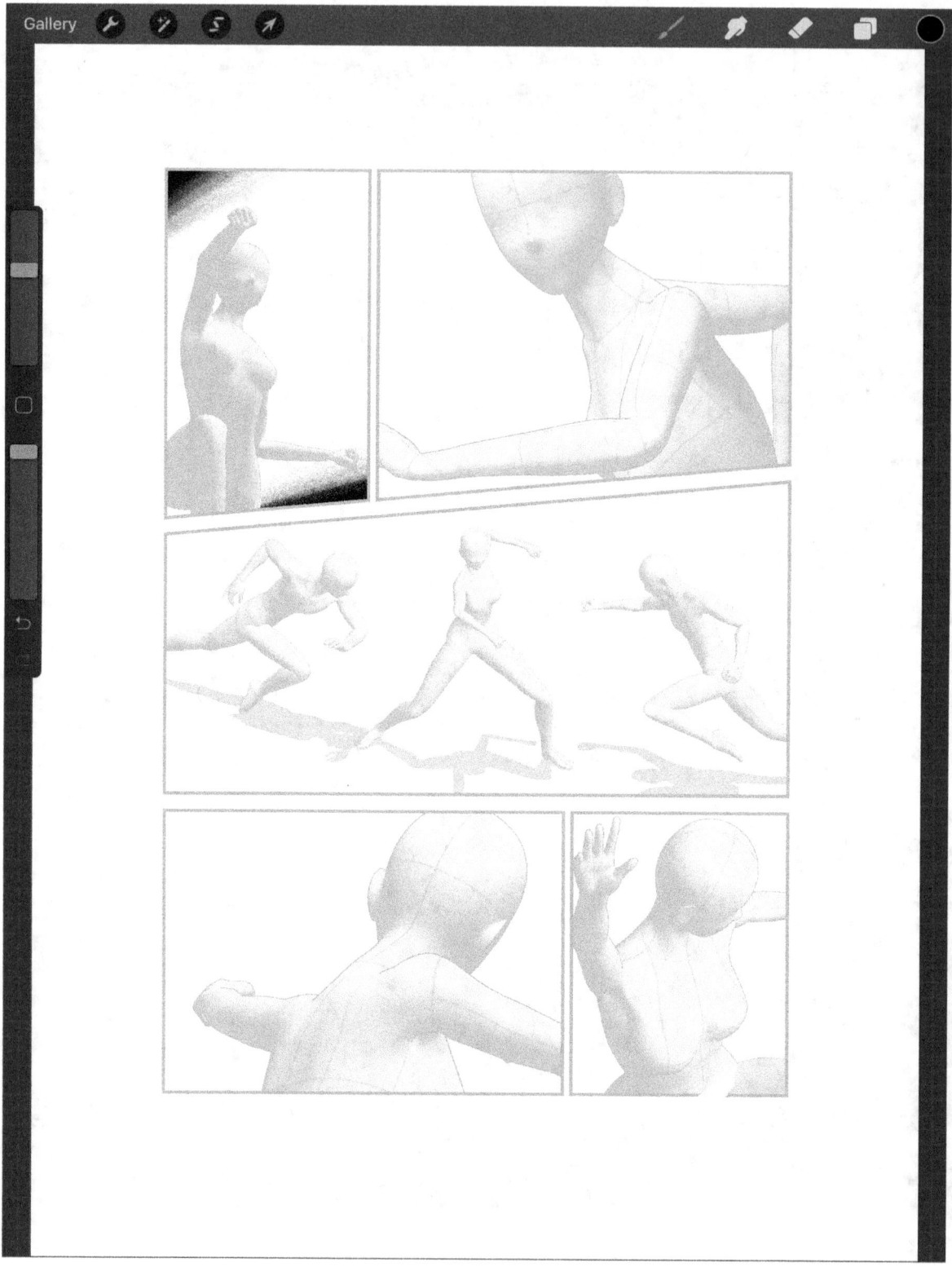

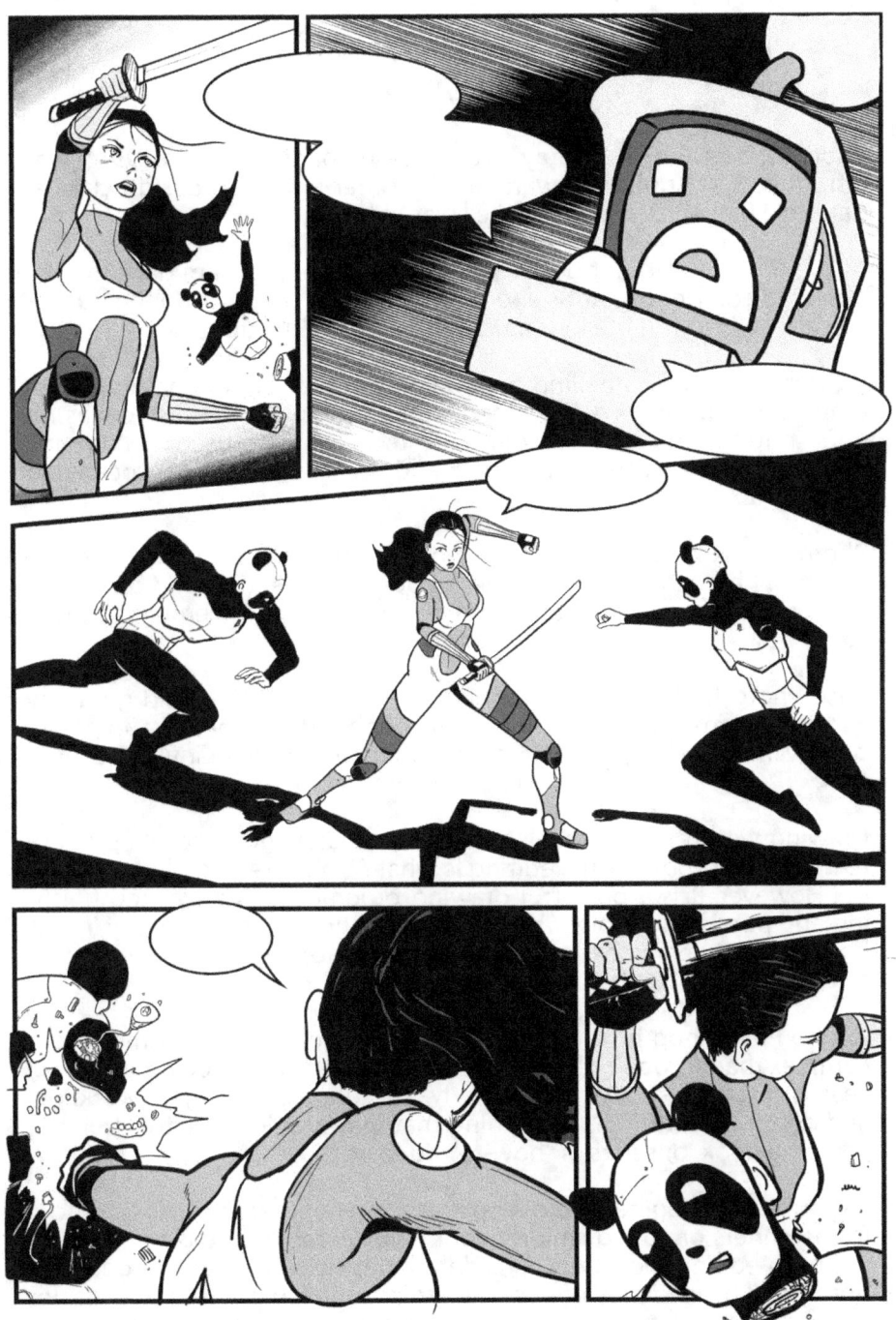

After creating the models and page layout in Clip Studio, I export a JPG into ProCreate where I use it as a template to re-create the page. After completing the drawings and shading in ProCreate I export to Photoshop for dialog and finishing work.

(above) Pre-dialog page, finished art for **Ethel the Cyborg Ninja 2**.

ADOBE PHOTOSHOP
- $$$$ -

Photoshop was my first foray into the world of digital art in 1993. I was introduced to Adobe software at a summer industrial design class at Carnegie Mellon University while I was in high school.

At the time, I could not believe that a computer program gave me the power to edit photographs and create complex graphics on the screen. I recall playing with the lens flare feature a lot (I still do.)

Previously, the foul-smelling darkroom was reserved for editing photographs. Airbrushing was confined to the art studio, and there was no undo button (and no Internet.) Back in the day, we used to combine multiple images with Scotch tape and scissors before photocopying them on a Xerox machine.

Photoshop is now as much a part of our culture as fast food and the Internet. Photoshop has become a noun, an adjective, and a verb; to Photoshop something is to alter it visually, usually by enhancing it in some way.

I use Photoshop for everything; in fact, I don't think I could go a day without it. I may draw with ProCreate, Clip Studio, or pencil and paper, but my images always hit Photoshop on their way to their final destination.

Drawing within Photoshop is possible, but drawing is not its primary feature. All-purpose visual editing is what Adobe created Photoshop to do. However, it is a powerful drawing program with advanced finishing and publishing tools, which is why I'm showcasing it heavily in this book. Though many readers may find Photoshop's array of complex features bewildering, it has thousands.

Adobe Photoshop is not software for beginners; it is 500 times more complex than Adobe Sketch on a tablet (it can also do 500 times more.) Learning to use Photoshop properly, and understanding its workflow and depth of features, is something that may require an actual training course, a book, or series of "how-to" videos.

As you might imagine, Photoshop is extremely expensive. It is not a tool for beginners or young children, but If you're looking to do serious art or photo-editing then it is a consideration, albeit an expensive one for a hobbyist (I believe they offer student discounts, something to consider if you are, in fact, a student.) Photoshop's front end and back end tools are the best in the business.

Adobe offers a scaled-down version of their full software called Photoshop Elements, which appears to be aimed at people looking to touch-up their photographs; it does not have Photoshop's powerful drawing tools. Avoid Photoshop Elements for drawing; buy ProCreate or Clip Studio Paint Pro instead, or use Adobe Sketch (which is free.)

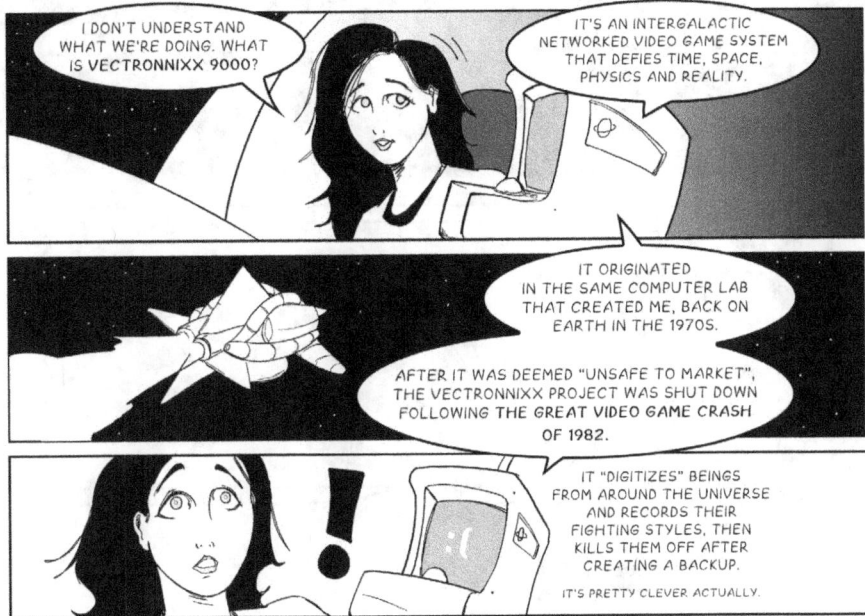

Photoshop's greatest strength for you, the digital drawer, is its multi-layer design, finishing, and refinement features. It is the best program available for taking your drawings (digital or physical) and completing them for online publishing or print.

I'll detail this more in the "workflow" section of this book, but when I create my comics, character designs, and artwork, I almost always sketch ideas with the free version of Adobe Sketch on iPad, or ProCreate, and then transfer my drawings to Photoshop for later refinement and inking.

I start by dropping the original sketch from iPad onto its own "sketch" layer and then draw over it in a finished "inks" layer. Just one of my completed manga pages can have up to 100 layers of sketches, drawings, frames, dialog, text bubbles, background shading, model photographs, and motion effects.

Anything is possible inside Photoshop, provided you have the hardware to run it. When budgeting out your digital drawing setup, don't forget to include a hefty computer if you plan to use Photoshop (or any high-end graphics or modeling program). Adobe eats RAM for breakfast and punishes lesser, obsolete computers with slow rendering times, drawing lag, and buggy performance.

The comic book panels above are taken from my book Ethel the Cyborg Ninja (2015) which was my first all-digital book. It me took a full year to learn to draw entirely digital in Photoshop!

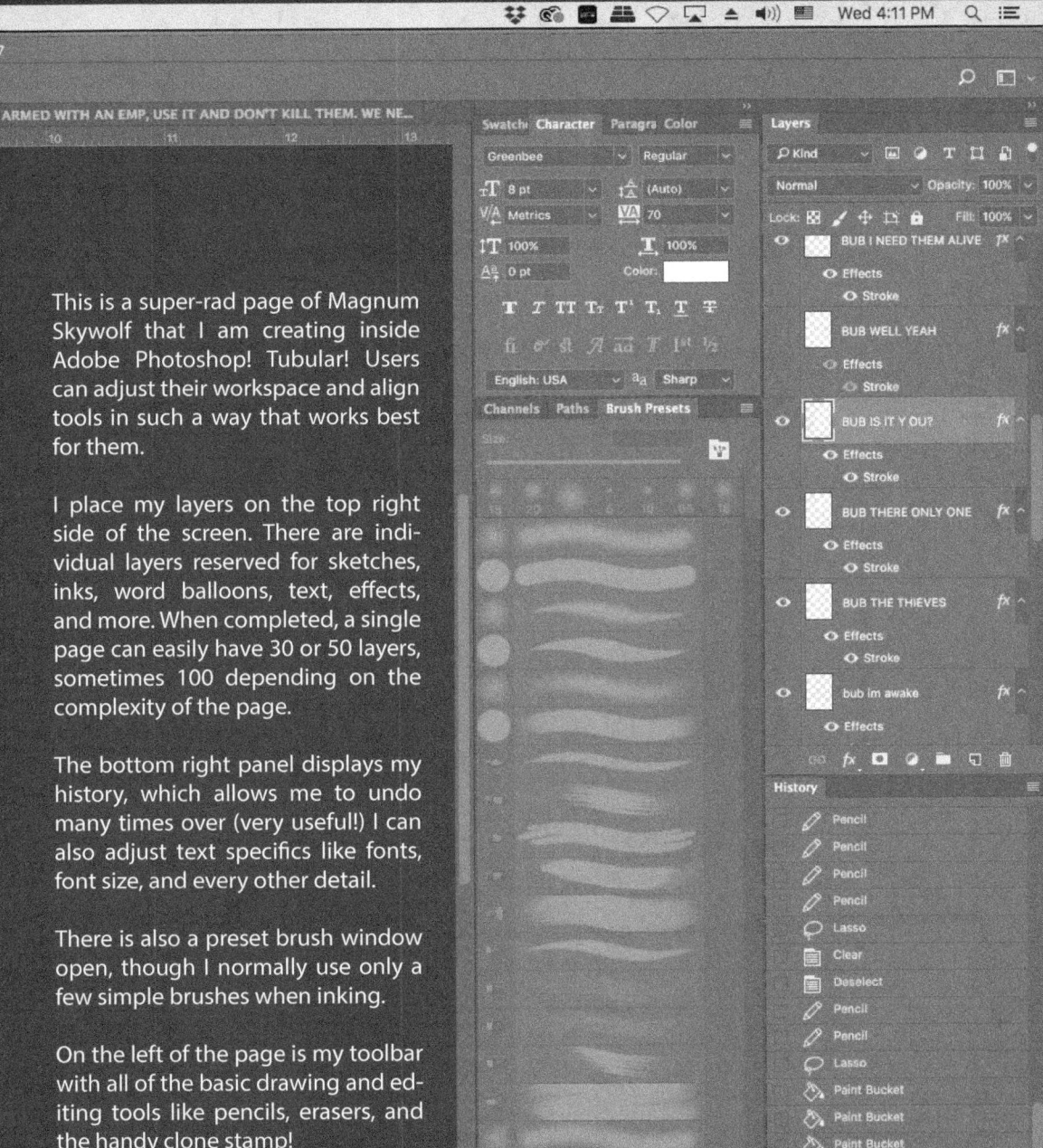

This is a super-rad page of Magnum Skywolf that I am creating inside Adobe Photoshop! Tubular! Users can adjust their workspace and align tools in such a way that works best for them.

I place my layers on the top right side of the screen. There are individual layers reserved for sketches, inks, word balloons, text, effects, and more. When completed, a single page can easily have 30 or 50 layers, sometimes 100 depending on the complexity of the page.

The bottom right panel displays my history, which allows me to undo many times over (very useful!) I can also adjust text specifics like fonts, font size, and every other detail.

There is also a preset brush window open, though I normally use only a few simple brushes when inking.

On the left of the page is my toolbar with all of the basic drawing and editing tools like pencils, erasers, and the handy clone stamp!

ADOBE ILLUSTRATOR
- $$$$ -

I have never been a huge fan of Illustrator because I first learned to draw digital in Photoshop. Photoshop is a raster-based drawing program; Illustrator is vector-based. They are two very different programs with different qualities and workflows. They are apples and oranges, but both useful in their special ways.

Someone who knows what they're doing can create a masterpiece with Illustrator. I can barely draw a circle. Drawing with Illustrator is hard (in my opinion!)

Adobe created Illustrator for those looking to draw and create images for professional print work, advertising, and logos. It is a far better program for creating graphics that can be scaled up or down to any resolution. Vector graphics are based on points and not pixels, thus making them infinitely scalable. You can make a drawing and scale it to the size of the building!

I can't draw a straight line, circle, or smooth curve to save my life. Illustrator is good for that because it does it for you, but you'll need to learn how to use it first. I have found the learning curve inside Illustrator to be even greater than Photoshop. It's a tough program to "pick up and play."

I rely on Illustrator when I want to draw things with wide, sweeping curves like balloons, horizons, and sword blades. Illustrator is great for making boxes with curved edges. I use it when creating packaging designs with crisp lines and design features that need to be scaled up and down.

I created the drawing of Edit-Station 1 on the previous page with Illustrator, and you can see the cleaner, smoother lines. Artists are also able to draw in Photoshop using Photoshop's better drawing tools, and then convert those drawings to vector graphics with Illustrator. Photoshop and Illustrator work well together once the artist learns to use them.

I prefer imperfect lines, perhaps because I am bad at drawing them; also because I tend to draw by sketching. Illustrator drives me nuts. I use it often for my t-shirt designs though, because I create sketches in Photoshop and then convert them to vectors afterward. Learning to use it properly will require a great deal of time and practice. Adobe offers books and tutorials for those interested.

Like Photoshop, Illustrator (the full version sold now as Illustrator CC) is overkill for beginners and young kids, but something to consider as you advance academically or professionally.

CHAPTER 4:
DIGITAL DRAWING BASICS

The basics of drawing digital are straight forward and easy to pick up. Slide something across the tablet screen and make art!

There's more to it than that if you want to get serious, but digital art creation is fun and easy to experiment with because there are no consumable supplies like ink and charcoal.

No matter what drawing program, tablet, or input mechanism you use, there will be options that replicate real-life tools such as pencils, pens, crayons, markers, and brushes. I suggest diving in and playing with all of them to see what they do (it's free, why not?)

The squiggly lines below were drawn with four different brushes in Adobe Sketch. Tapping the tools on the left side of the screen brings up options like the type of sketch brush. There are many brushes to choose from that dramatically change the look of your design.

To access all of the options, hold your finger or digital pen on top of the tool until it displays things like brush size, opacity, and color. With a bit of practice, you can make practically anything imaginable.

You control the brush size by sliding its slider up and down. Brush size adjusts the size of the stroke on screen from a tiny line all the way up to a thick marker-like stroke or wide paintbrush.

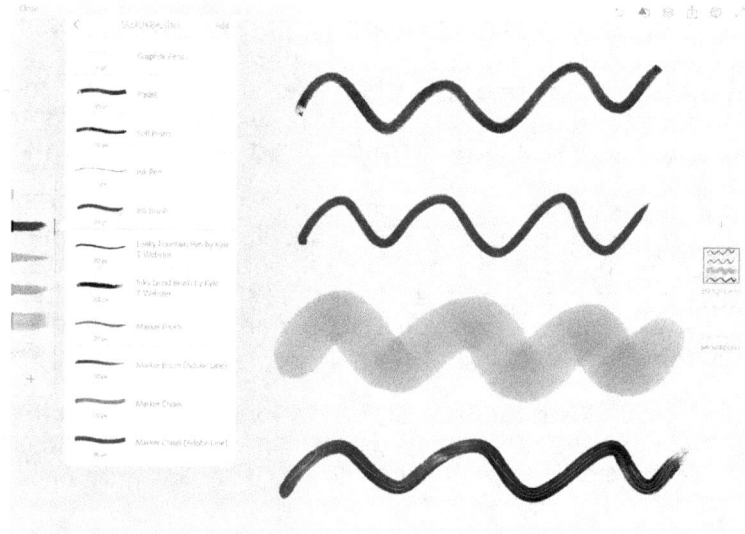

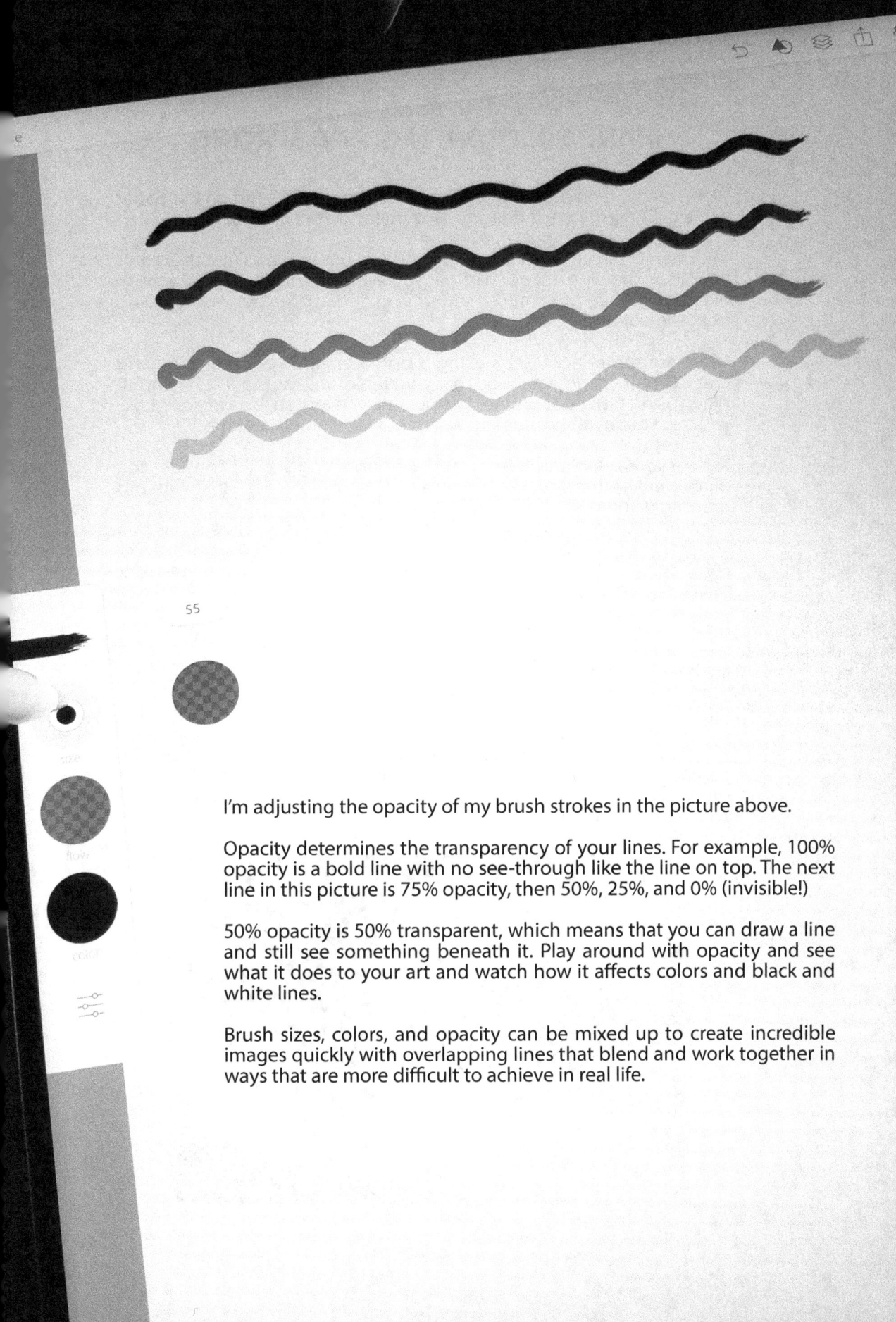

I'm adjusting the opacity of my brush strokes in the picture above.

Opacity determines the transparency of your lines. For example, 100% opacity is a bold line with no see-through like the line on top. The next line in this picture is 75% opacity, then 50%, 25%, and 0% (invisible!)

50% opacity is 50% transparent, which means that you can draw a line and still see something beneath it. Play around with opacity and see what it does to your art and watch how it affects colors and black and white lines.

Brush sizes, colors, and opacity can be mixed up to create incredible images quickly with overlapping lines that blend and work together in ways that are more difficult to achieve in real life.

HAND POSITION, LAG, AND SPACING

When drawing on paper, most of us tend to rest our hand on the paper while guiding the pen's delicate movements with our fingers.

On paper, this can lead to some smudges, but in digital it can lead to your hand drawing images without you even realizing it. This is because most tablets are not smart enough to differentiate your resting hand from the point of a pen.

There are some tricks like placing a cloth beneath your drawing hand that can reduce the likelihood that your tablet will register it as an input. When using tablets or phones with an entry-level pen, be wary of where you rest your meat hooks (and watch out for extraneous lines!)

Serious artists looking to move beyond doodling should consider the bigger and better tools like iPad Pro or Wacom, tools designed with pro drawing in mind.
Drawing tablets like the Wacom are smart enough to detect the pen and not your hand while both are resting on the screen. The iPad Pro and Apple Pencil are also very good at differentiating between the two, but not perfect.

Unlike real-life drawing, digital drawing can suffer from "lag" which means that your tablet or computer shows the stroke that you are drawing a moment after drawing it. This varies by program and tablet/computer. Some people find lag infuriating.

Lag is most noticeable when drawing quickly or making fast shading marks on the screen and can be very distracting. If lag is a problem, experiment with different drawing programs or consider a new computer. Faster computers and tablets mean less to no lag, slow computers are bad for drawing. Very bad!

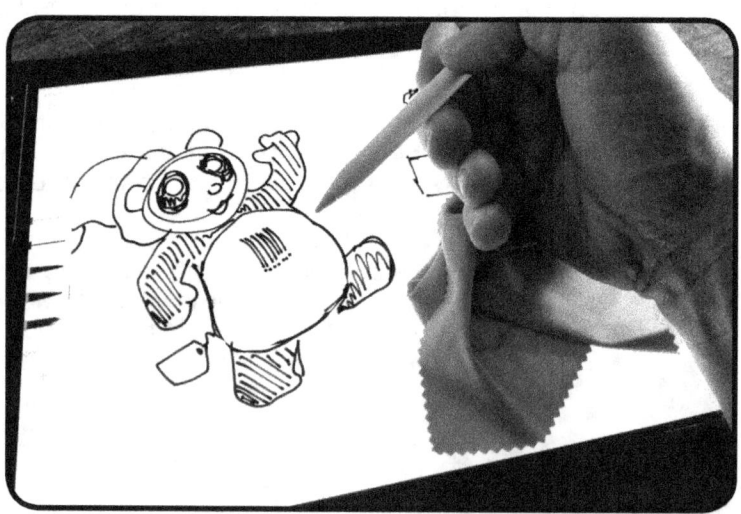

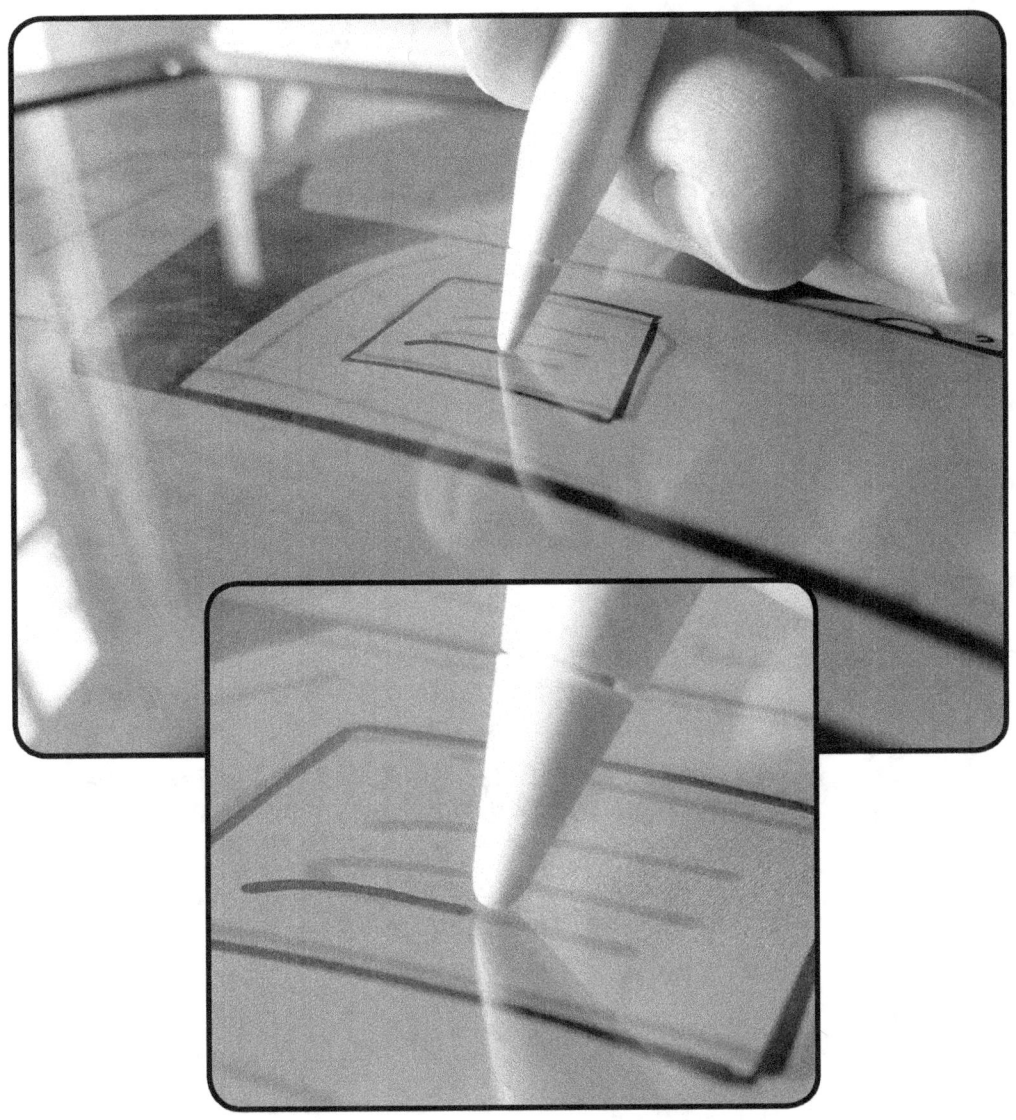

Extreme close-up of me drawing on my iPad Pro with Apple Pencil. Can you spot the gap in between the pencil and the line under the glass screen?

There's little that you can do about the tiny gap between your pen and the screen when drawing on a digital tablet because there is a layer of glass (or plastic) in between your pen and the actual screen. This is a huge change from looking at a real pencil making real lines on real paper, but give it time, and I think you'll quickly get used to it.

I never even notice the gap anymore, one could say that I don't mind the gap (That's an awful joke.)

SKETCHING AND INKING

Back in the day, comic book artists and cartoonists drew sketches with pencils, inked over the pencils, and then erased the pencil marks. In some cases, teams of people worked together with special tools like blue pencils and fancy scanners.

Sketching, or penciling as I frequently refer to it, remains an integral part of drawing because the sketch is an underlying foundation that supports the completed drawing. Beneath layers of inks, colors, letters, and explosions is a sketch (which readers of the final product typically never see)

You'll hear me refer to sketching as penciling throughout this book. Traditionally, when working on paper, I use a pencil to sketch and then complete my drawings by inking over my lines with a pen. When drawing digital, I sketch, create a new layer, and draw over it again with finished lines that I call inks (I cover layers on page 64.)

This is one of my favorite parts of digital drawing because I approach sketching and inking from different mindsets and often doodle (and sketch) on my iPad when I'm feeling creative. I ink when I'm feeling focused.

Pictured below is a quick sketch of Edit-Station 1 and Surf Panda that I drew using Adobe Sketch. I scribble loosely and form the layout and characters with "pencil lines."

Pictured below is the completed drawing of Edit-Station 1 and Surf Panda that I finished in Adobe Photoshop.

After sketching the picture in Sketch, I copied the drawing into Adobe Photoshop. Photoshop has better tools for making solid pen-like lines and filling in shapes and is, therefore, a better program for inking.

I pay close attention to the finished drawing when inking because these are the completed lines that the reader will see. Depending on the drawing, the final lines should be smooth, the correct weight, and filled with personality.

When inking a finished piece of art, I close off parts of the drawing so that I can fill the space with color or grayscale, like Surf Panda's shorts and the Edit-Station 1 screen. In Photoshop, I quickly fill those spaces with the paint bucket tool.

The common theme of this book is that drawing digital doesn't make your sketches or inks look better than traditional media. Drawing digital makes creating your work more efficient. There's no need to erase sketches or pencil lines in the digital realm with an eraser, which is cumbersome, messy, and often destructive. I have a deep-seeded hatred of eraser dust!

Sketching and inking the same piece of paper typically eliminates the sketch. The pencils are gone forever when erased. When you sketch digitally in multiple layers, the sketch layer is made invisible but not erased. The sketch lives forever! This is good for social media posts when viewers want to see how you created your finished piece of art from start to completion.

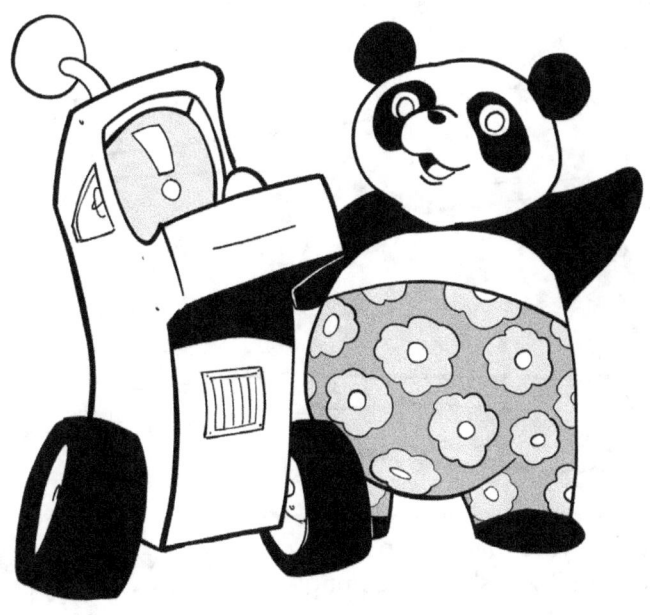

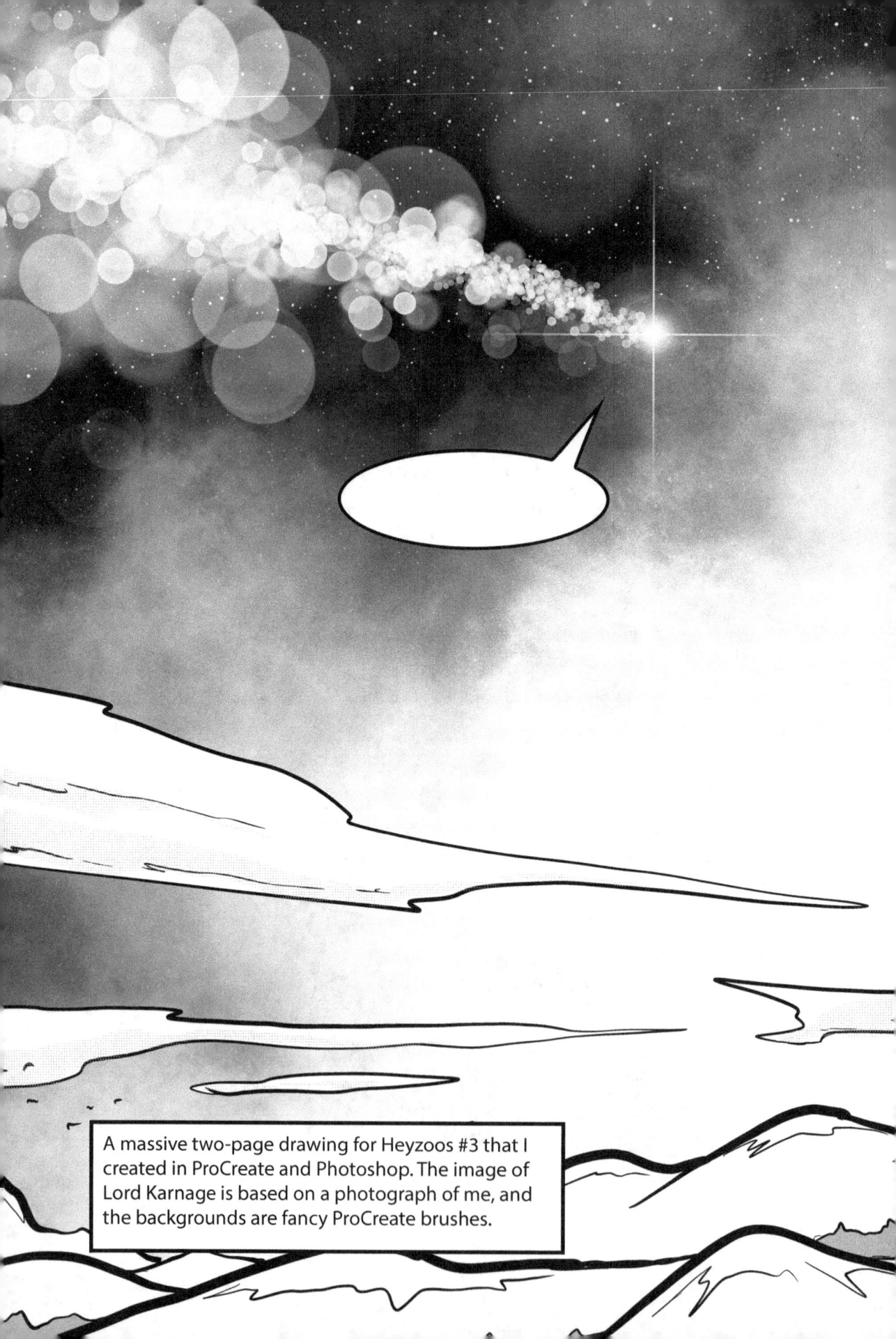

A massive two-page drawing for Heyzoos #3 that I created in ProCreate and Photoshop. The image of Lord Karnage is based on a photograph of me, and the backgrounds are fancy ProCreate brushes.

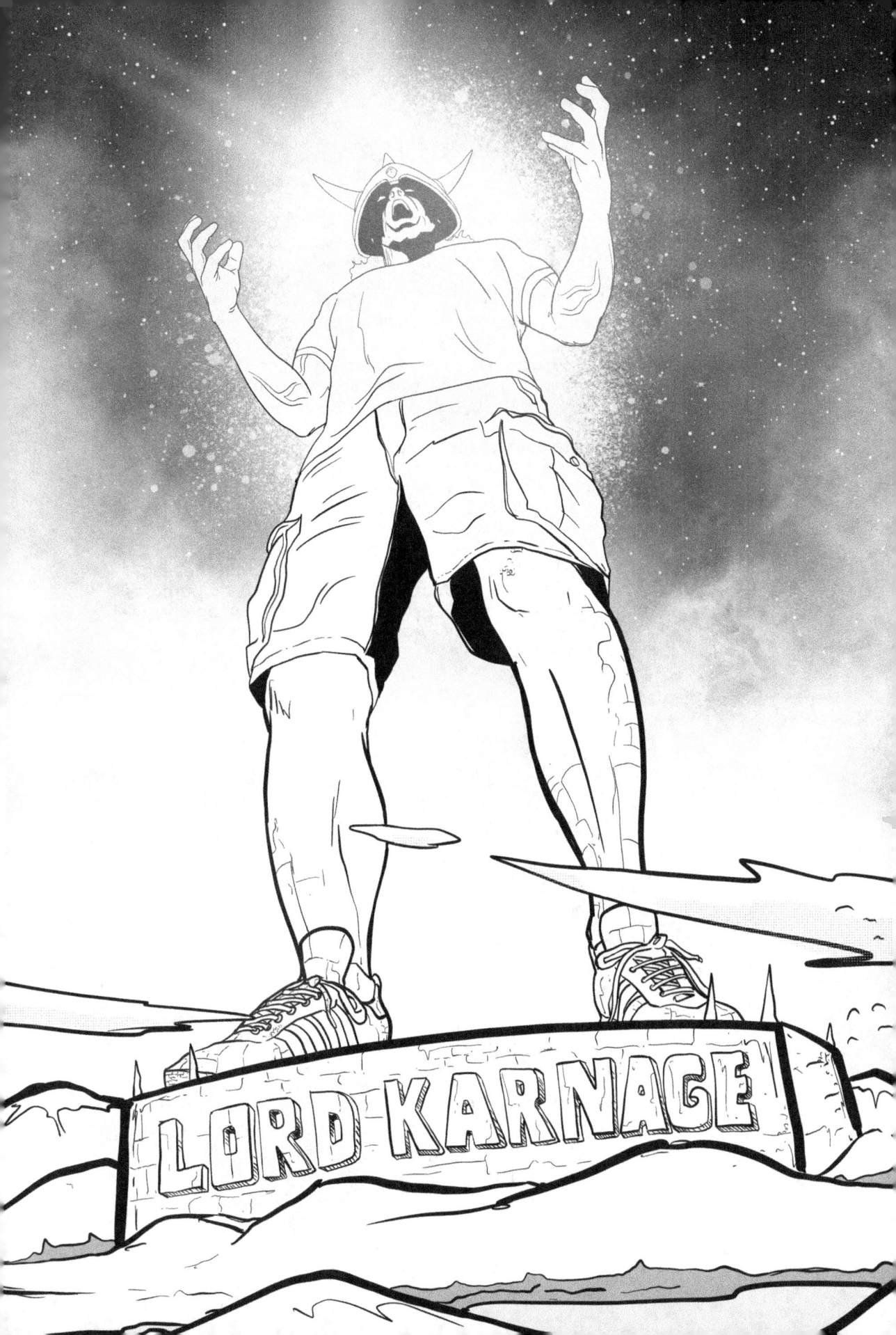

DRAWING IN LAYERS

Drawing in layers is the greatest thing since sliced bread. It's hard to imagine a time when people didn't draw in layers; it may be the greatest perk when drawing digitally because it effortlessly stacks and organizes sketch layers, ink layers, color layers, and finishing layers in one document. Artists can duplicate and save backups of layers in case things go awry and mistakes are made.

All of my finished comic book pages are comprised of multiple layers, sometimes more than 100. The next page shows a screenshot from a completed page of Ethel the Cyborg Ninja 2 with layers highlighted.

Layers allow for incredible creativity and flexibility because you can create individual layers for characters in the foreground, layers for backgrounds, layers for effects, and dialog. I'll draw a rough storyboard and make it its layer. Then I add sketch layers, model layers, and inking layers until the entire page is complete.

When done, I make the rough sketch layers invisible so that the reader never sees them in the finished product! For demonstration purposes I'll walk you through my layer process by creating a page of an upcoming book called Cosmic Death Brick Adventures, starting with my storyboard layer drawn on iPad.

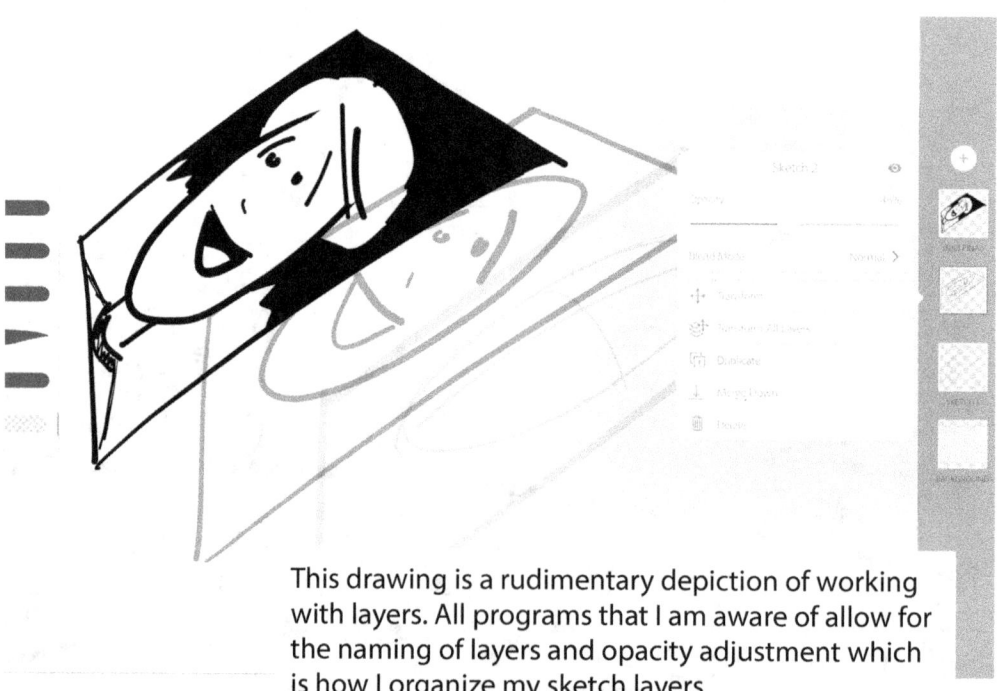

This drawing is a rudimentary depiction of working with layers. All programs that I am aware of allow for the naming of layers and opacity adjustment which is how I organize my sketch layers.

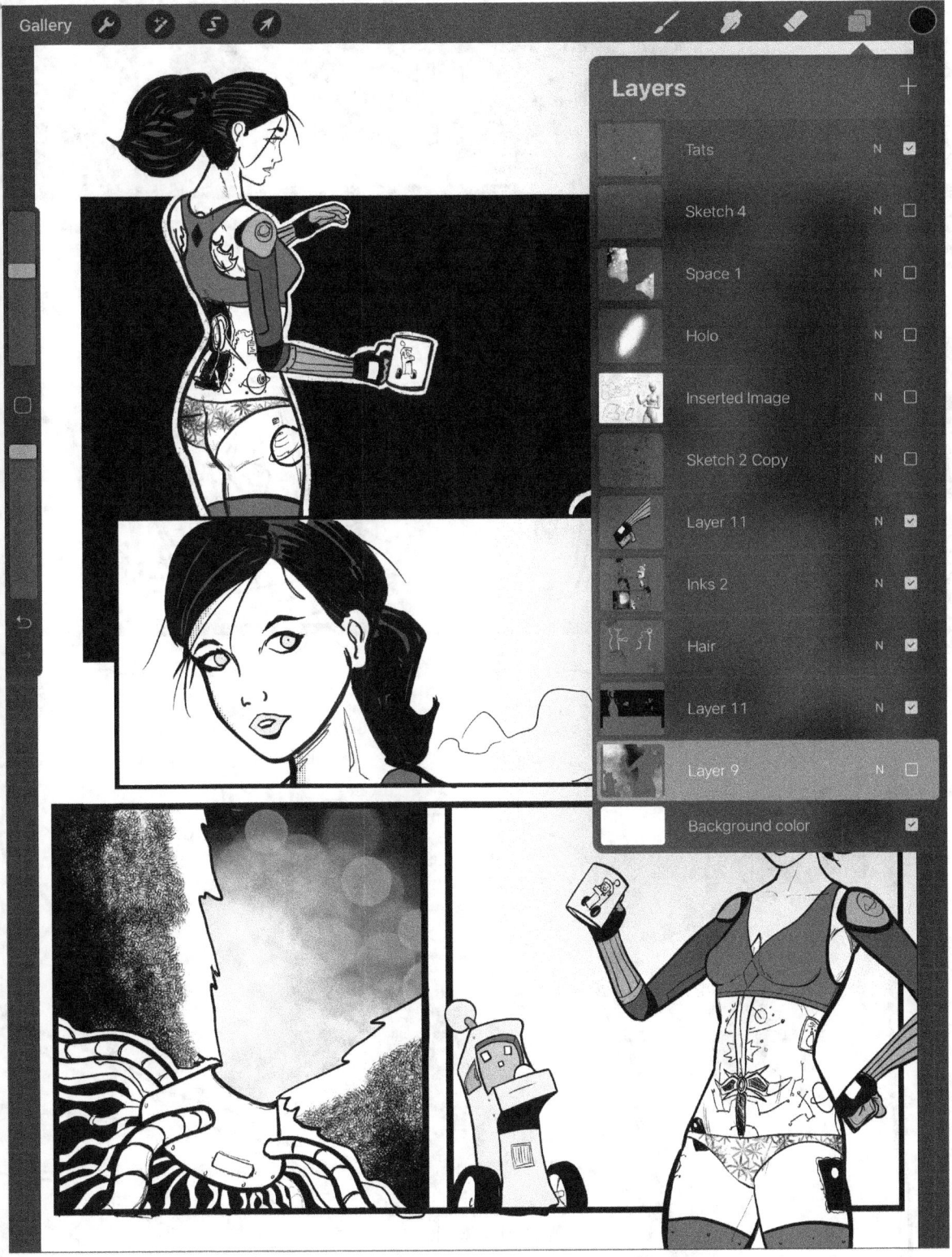

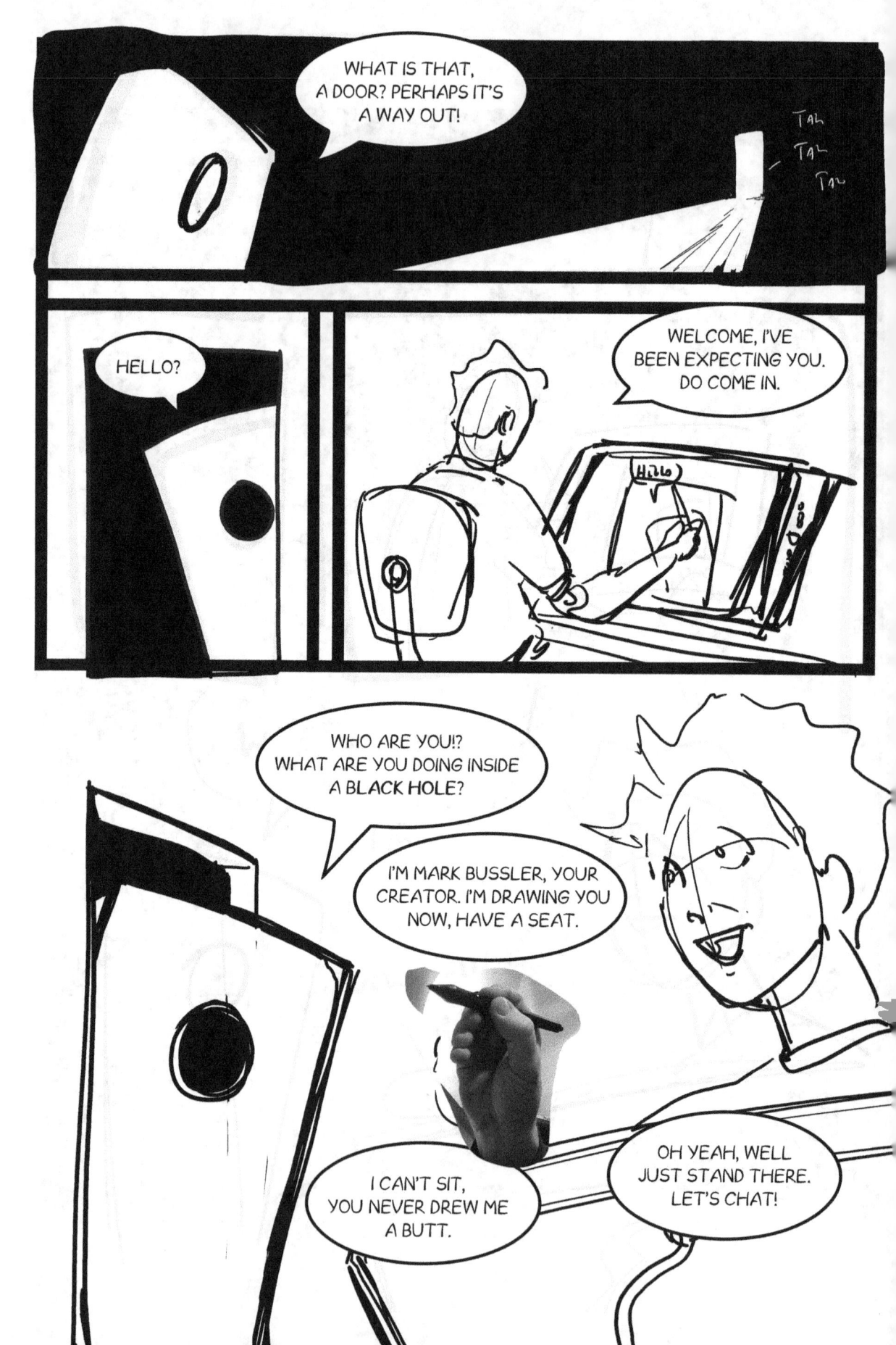

Pictured on the previous page is a full-size comic book page that I am creating inside of Adobe Photoshop.

If you look closely, you can barely make out the original storyboards in the background, which I set to 15% opacity. I used the storyboard layer as a guide when creating my first round of refined sketch layers.

Pictured above is a screenshot of this document next to its layers inside of Photoshop. I have organized the layers and labeled them so that I can easily make changes to certain panels without affecting others.

Working in layers allows me to design the page as a completed work of art without disturbing parts of the design that I went left alone. I'll slide word balloons and dialog around the screen (on their own layers) until it looks right and reads well. Years ago this was a job that required many people!

I have created groups of layers for the text and word balloons (which I call "Bub"), the word balloon layers have been collapsed in this screenshot for demonstration purposes.

Once again, I used my hand as a model. I photographed it and placed it on its layer. I'm happy with the sketch and layout and will now move to inking!

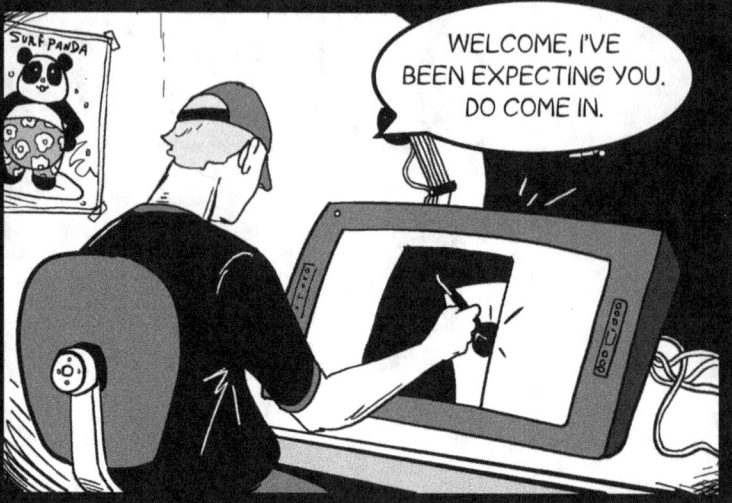

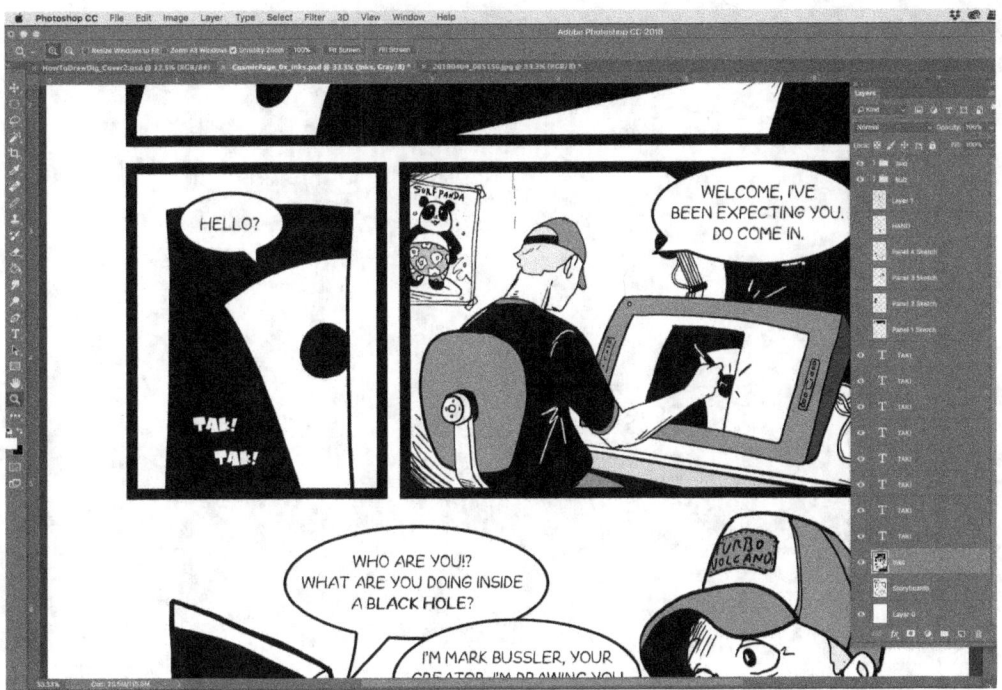

Hooray! The page is finished, or at least it's finished for now. I haven't wrapped up Cosmic Death Brick Adventures yet, but I'm fairly confident this page won't change much.

Upon completion, this page has 31 layers, mostly text layers. Each line of dialog and every sound effect gets its own layer because I slide words around the screen to position everything properly.

This page is a good representation of my workspace, simple but effective. I always have a desk lamp aimed at the wall because I find that light coming from behind the screen is better than light bouncing off the screen. Nobody wants light reflecting off their Wacom monitor, that's not cool.

After saving this page in cloud storage (which is always backed up), I'll make a copy to prevent clumsy 'ole me from accidentally flattening the image and losing my layers. There are few things worse in life than inadvertently flattening a page and needing to move text or replace word bubbles later.

I hide the sketch layers after inking so that all you see are inks. The original storyboard (sketch) layer is still there but invisible, as you can see from the picture to the right.

DRAWING WITH PHOTO-TRACING ASSISTANCE

This is a somewhat controversial technique, but it shouldn't be, artists have been using models since the dawn of time. Portrait artists look at people; landscape painters look at a landscape while painting it.

Modern phones and tablets take this model drawing concept one step further by allowing artists to photograph their subject and trace over the photograph. This is also commonly known as "lightboxing" because, before smartphones, artists could trace over photographs on paper using a lightbox.

For demonstration purposes, I'll use a cheapo drawing figure. Mine is plastic, but we've all seen the wooden drawing figures sold at art shops.

Using layer techniques from the previous section, I'll take a picture of the Body Chan brand model. After the photo session, I bring her into Photoshop where I sketch over the plastic form.

As pictured on the next page, this tool works well as a guide to assist in sketching out body positions, angles, and depth of field.

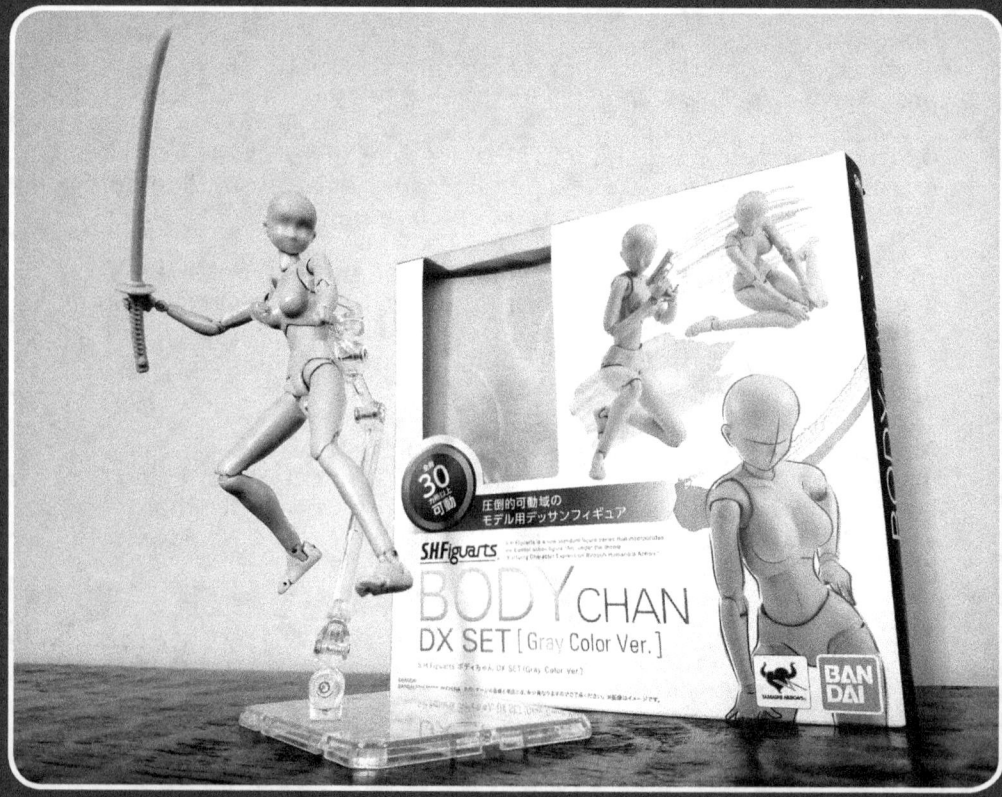

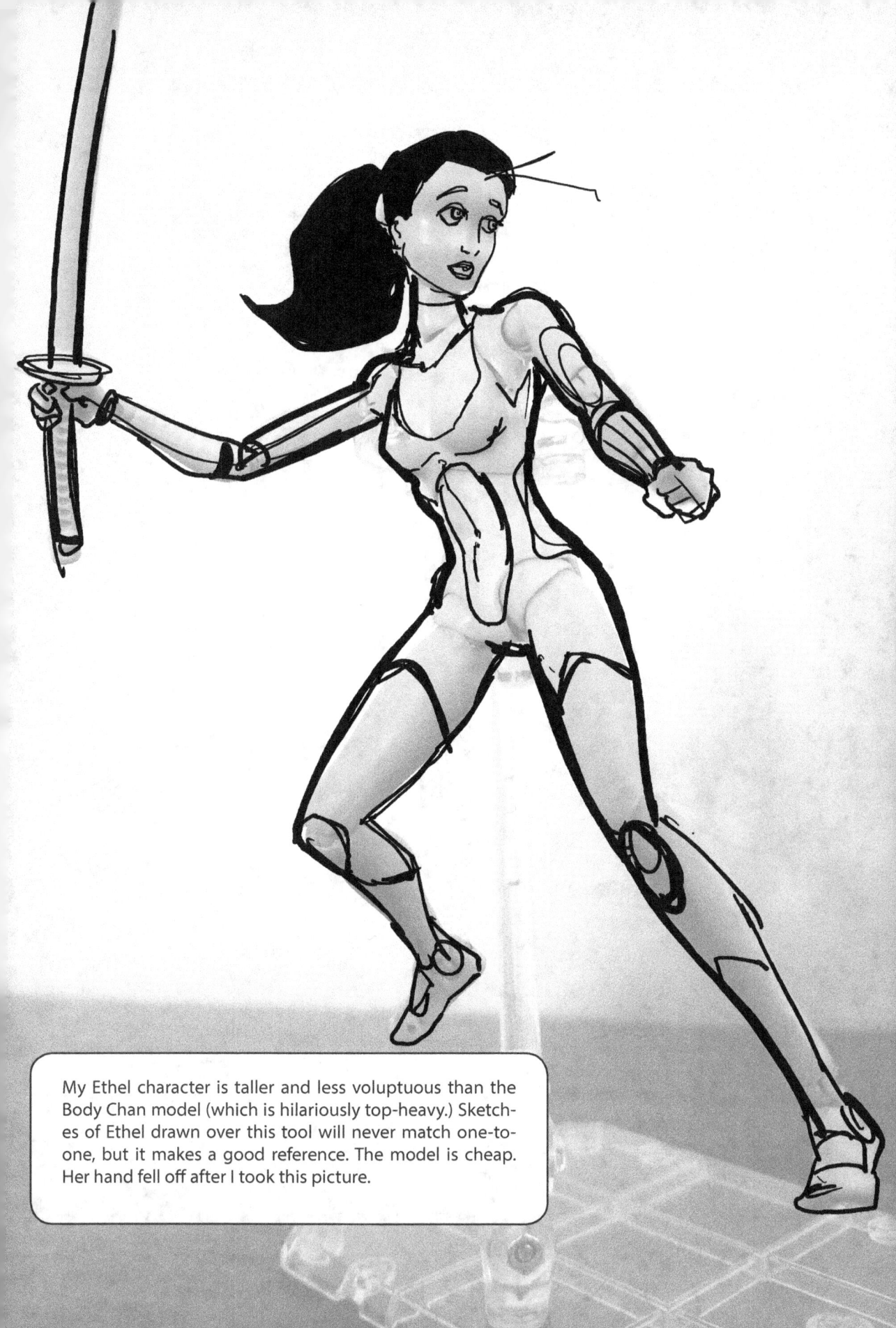

My Ethel character is taller and less voluptuous than the Body Chan model (which is hilariously top-heavy.) Sketches of Ethel drawn over this tool will never match one-to-one, but it makes a good reference. The model is cheap. Her hand fell off after I took this picture.

DRAW BY ZOOMING IN

Comic book and manga artists traditionally draw pages on oversized pieces of paper which are far larger than the printed size of the book. Drawing on massive sheets of paper allows artists to see more of the artwork and draw intricate details while "zoomed in."

Companies like Adobe have gone to great lengths to attempt to re-create the feeling of working with a full-size sheet of paper. Within Photoshop (and other programs), you can rotate the drawing, zoom in, and zoom out to highlight just the areas that you want to see.

While there's no substitute for seeing the entire page on the drafting table, drawing digital has perks like zooming way in on the detail.

Pay attention to the size and resolution of your drawings before you start them. For print work, I will typically create at 600dpi (dots per inch.) Most books print at 300dpi, 600dpi is better for backup and re-publishing. Internet requirements are much lower.

When drawing Vectronnixx 9000 for Heyzoos #3, I zoomed in on the part of my drawing to add incredible detail to the background.

PUTTING IT ALL TOGETHER

I'll walk you through the start to finish creation of a page from my book Ethel the Cyborg Ninja 2 (which amusingly was not actually used in the final book, but you'll get the idea.) I'm using all of the trickery described in previous pages.

The finished version of this page can be printed 8 1/2" x 11" in black and white. The completed resolution is 600dpi, and it will be saved as a layered PSD file (layered Photoshop document) for possible use in Ethel issue #3.

The first thing that I do is storyboard the page, this time in Adobe Sketch on my iPad. This is a scene where Ethel encounters another Space Tentacle Eyeball monster, one of the terrifying main antagonists from Ethel the Cyborg Ninja Book 1.

As seen on the next page, I'm designing a three-panel layout. There is a wide shot, a close-up, and then an action shot (which was initially depicted as a close-up, but I changed my mind.)

The storyboard starts with one layer. I draw the close up of Ethel inside Sketch (on page 76) and copy and paste it into an Adobe Draw document. Working in multiple layers, I refine the drawing and add more detail as seen on page 78. From there, the drawing is sent from my iPad to Photoshop where it will function as a draft layer, as seen on page 79.

Original page layout for **Ethel the Cyborg Ninja 2** drawn in Adobe Draw. Readers of Ethel 2 will notice that this page is not in the final version of the book, but it served as inspiration for some other pages after a re-write.

Ethel's close up is re-drawn in Adobe Sketch, copied and sent to Adobe Draw on its own separate layer.

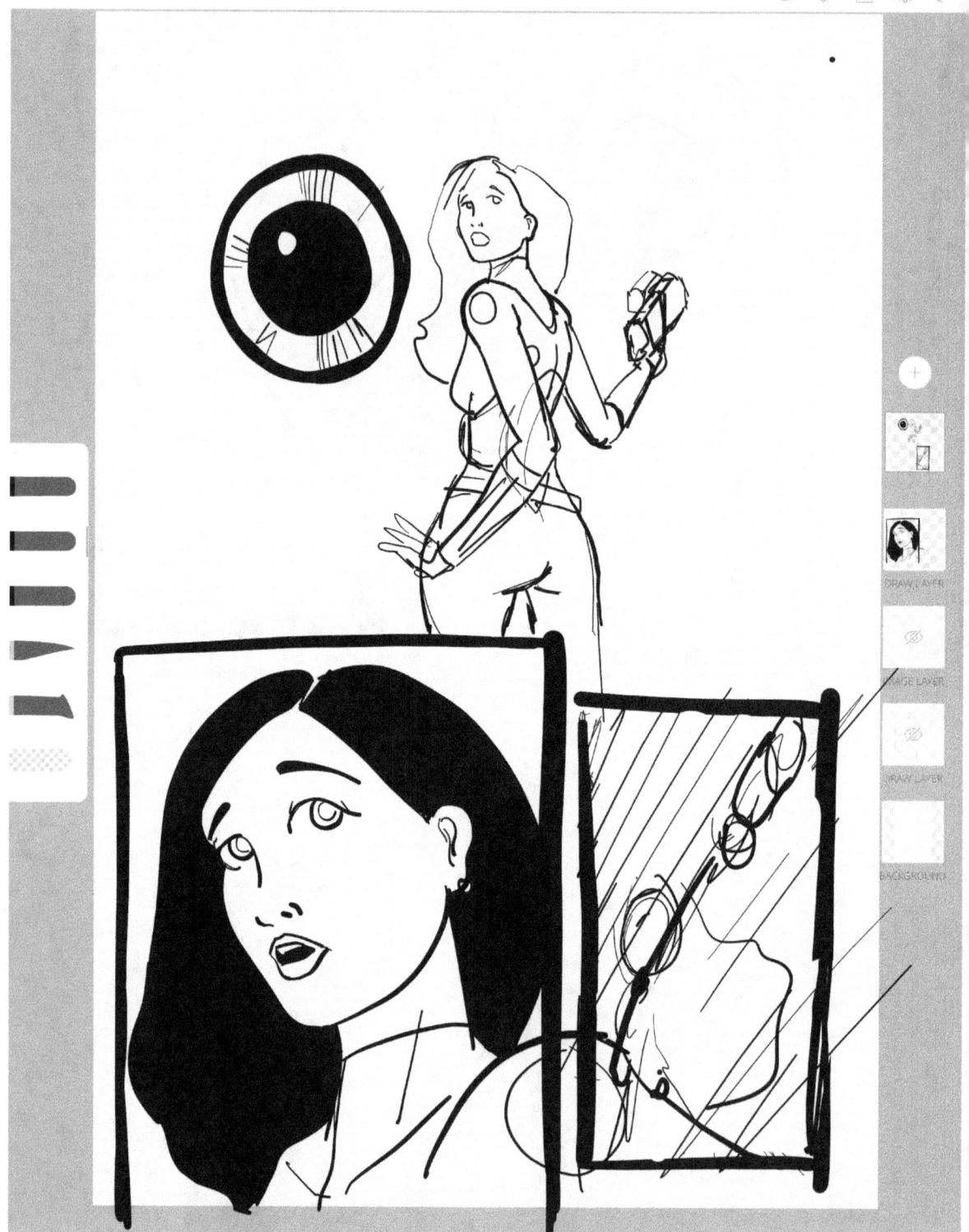

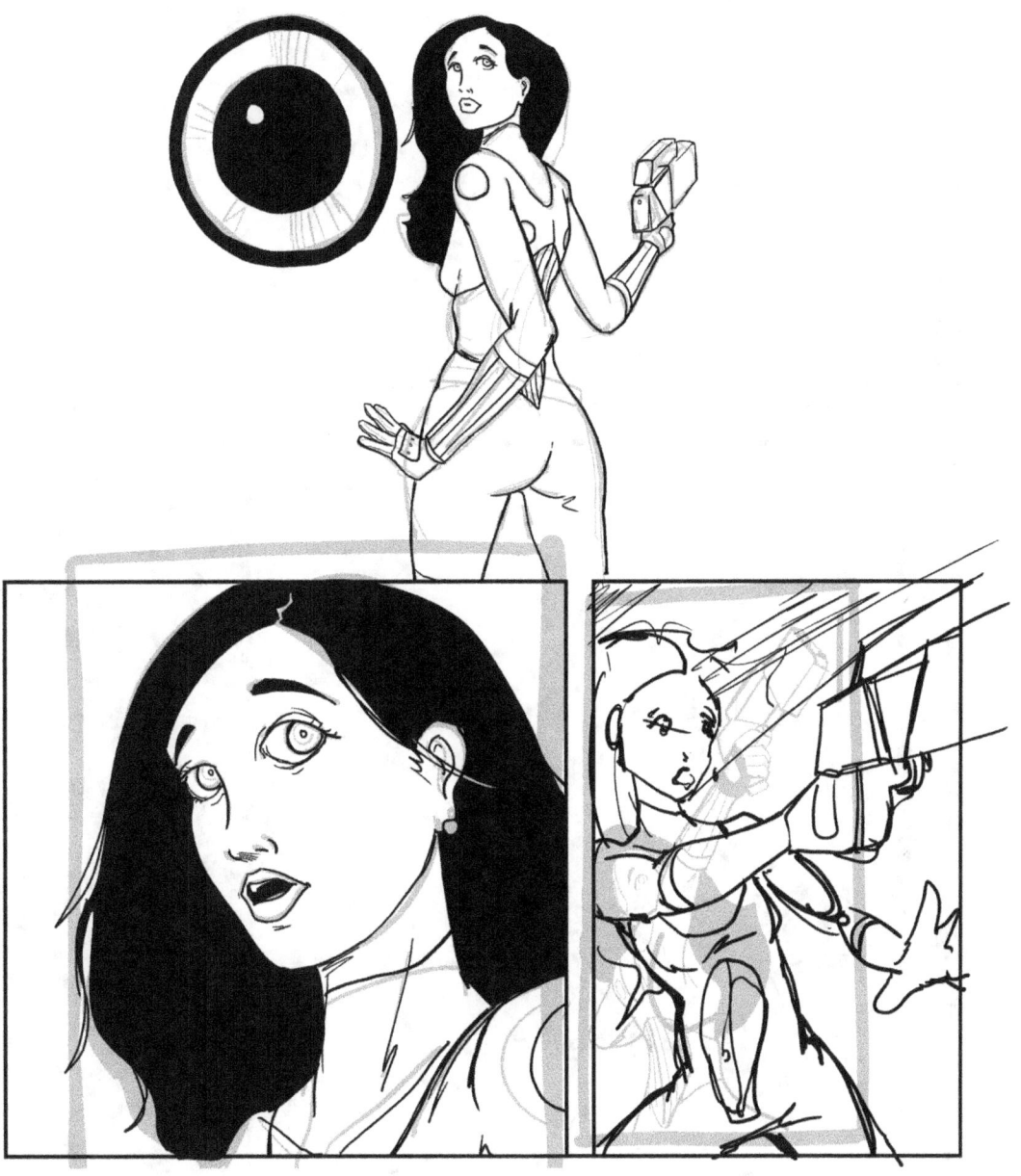

Pictured (left) Refined sketch layers drawn in Adobe Draw on iPad Pro. (above) The first pass of inks in Adobe Photoshop drawn over the sketch layer.

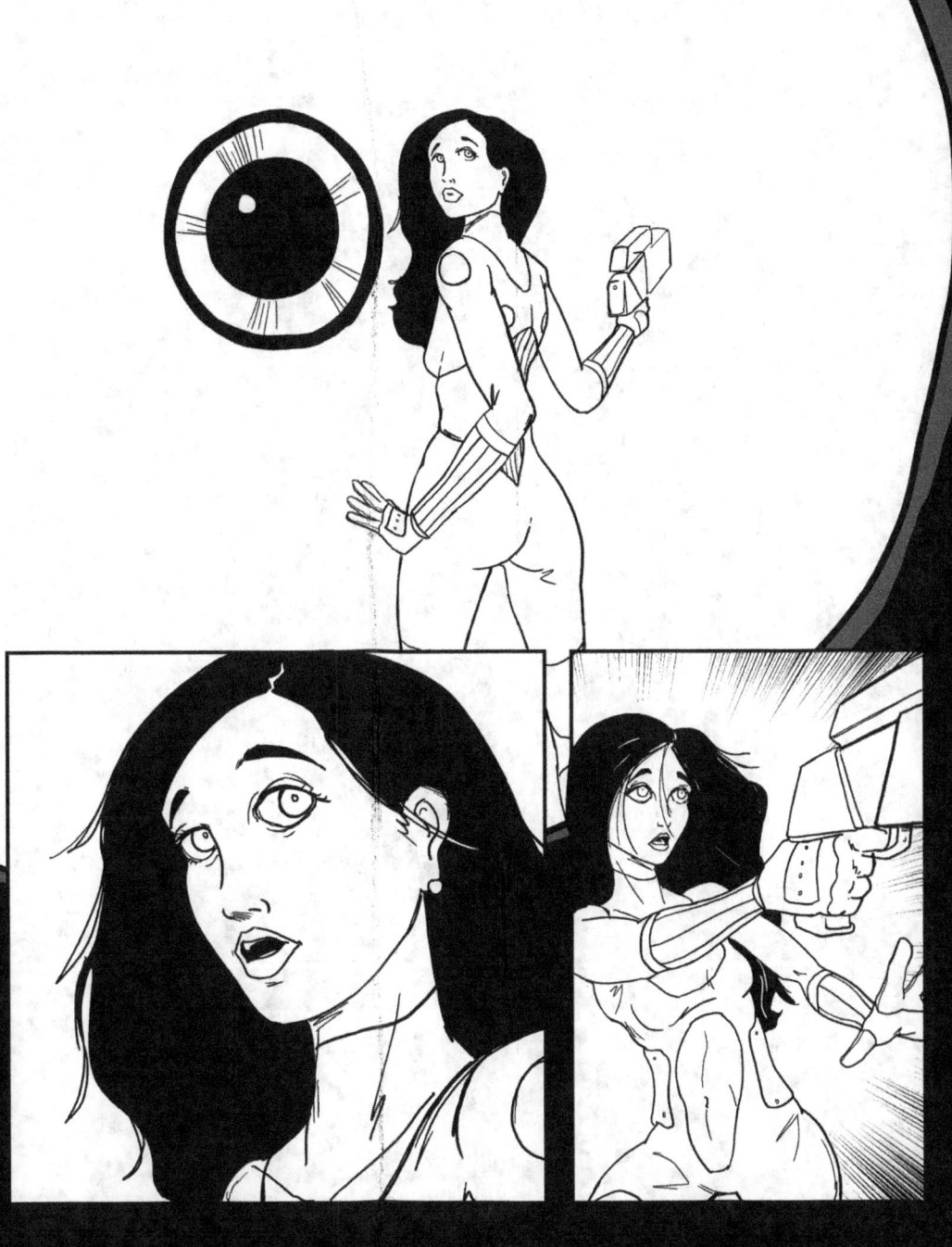

Pictured (left) Sketch layer over the Body Chan model replaces the original bottom right frame. (above) Refined inks in progress in Photoshop. I omitted this scene from Ethel 2 but may use it in a future issue (because who doesn't love eyeball monsters?)

CHAPTER 5: ADVANCED WORKFLOW

Digital drawing is not all that dissimilar from drawing on real paper in real life, but there are many differences, particularly when it comes to workflow. Creating a good workflow is fun and productive.

What is workflow? Workflow is the start to finish process by which you (the artist) begins and ends a project (a work of art.) A workflow can be as simple as drawing a picture on the iPad and publishing it, or it can be as complicated as using ten different programs to complete a page for print and other applications.

Think of your workflow as the system you use to create. My workflow to getting morning coffee is to carefully measure water by pouring it into the carafe, transfer the water into the coffee pot, insert the filter, put coffee grinds into the filter, brew the coffee, pour said coffee into my mug and enjoy!

A purely digital workflow makes digital drawing faster and more efficient, but it takes time to master. All artists have a unique style, tools, and special skills; everyone has to develop the individual workflow that works for them.

In this chapter, I will take you on a trip through my workflow. My workflow is a complex yet logical process that I have developed over the years to maximize productivity and finished art quality. Perhaps this is a voyage into the depths of insanity? I encourage you to use it as inspiration to create your start-to-finish workflow.

Keep in mind that a workflow requires room to evolve. I'm always adapting to new tools, new technology and various demands on my schedule. Between 2018 and 2019 I changed my workflow dramatically and included tools like ProCreate into the mix. I went back to physical storyboarding with pencils for certain pages because I like the way that I draw eyes better with a pencil, and then I finish the drawings in ProCreate and Photoshop.

GRAPHIC NOVEL WORKFLOW OVERVIEW

- Step 1: Storyboard
- Step 2: Modeling
- Step 3: Inking
- Step 4: Finishing
- Step 5: Publishing

A completed page of art for **Ethel #2** drawn in ProCreate on iPad.
The dropdown shows my favorite brushes.

MARK'S WORKFLOW

My workflow is a five-step process that results in a finished comic book that will be printed and sold. Selling a product is serious business, and I want consumers to be happy with their purchase and hopefully come back for more.

My priority is that the story and artwork be professional, memorable, and thoroughly entertaining. Competition is fierce, and most of the artists that I am competing against do this full time. Consumers don't care. Their money is money, and they expect my work to be as good as anything coming from Marvel or DC with a team of people (but I have loads of digital tools!)

My second priority is speed and efficiency because drawing is only about one-third of my job. Most of my real-life work time goes into writing, marketing, and video production (the glamorous life of a self-publisher!) There is never a week where I can devote all of my time to comics. Therefore I have to be fast and efficient! Let's enjoy the process:

WORKFLOW STEP 1: STORYBOARD

After writing a rough plot, the first thing that I do when creating a graphic novel, comic book, or manga is to sketch the entire idea on an iPad using ProCreate. This is what I refer to as the "storyboarding" process.

When storyboarding, I scribble notes and write dialog to craft pages that drive the story and make good art. At first, it looks like a mess, but what I'm doing is working out the flow of the book, developing the page layouts, and writing dialog all at the same time. Even though most of this book (the one you're reading) focuses on art, it is characters and plot development which remain the most important part of a comic book.

The iPad Pro is my favorite tool for storyboarding because I can write and draw wherever I am (I don't like to sit in an office all day.) The iPad is ideal for scribbling and sketching; it is fast and efficient. I get ideas from looking at my work and can also take photos of things to develop into backgrounds, models, or set pieces.

I save all of my sketches and upload them to "the cloud." I can easily organize my storyboards into pages, and then shuffle pages around. I like to see how a book comes together as if I was reading it for the first time.

Pages and drawings often go through several layers of doodles, sketches, more refined sketches, and finished sketches before completion. Later, when I'm happy with page layouts and the storyline, I'll copy the pages into Photoshop for the next steps.

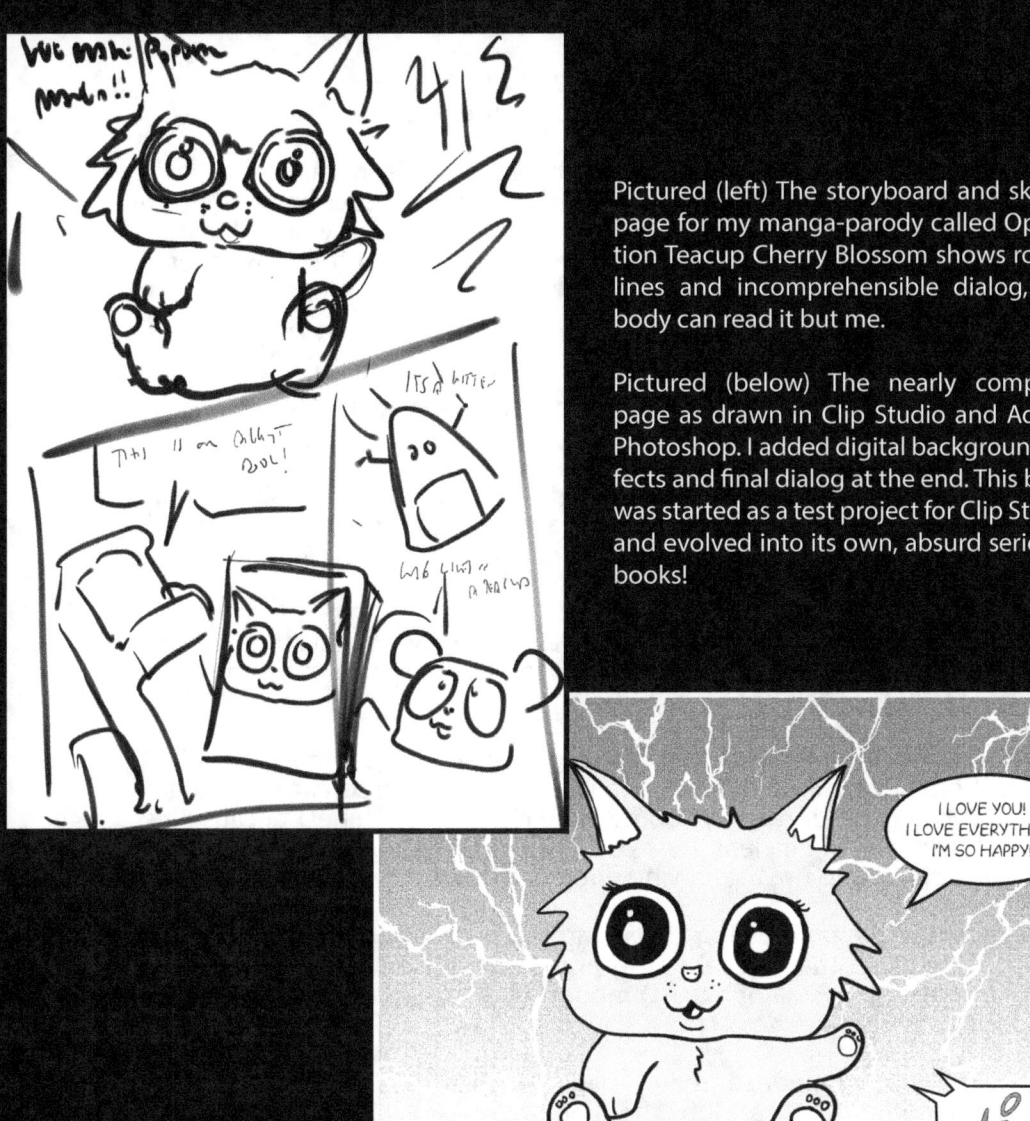

Pictured (left) The storyboard and sketch page for my manga-parody called Operation Teacup Cherry Blossom shows rough lines and incomprehensible dialog, nobody can read it but me.

Pictured (below) The nearly complete page as drawn in Clip Studio and Adobe Photoshop. I added digital background effects and final dialog at the end. This book was started as a test project for Clip Studio and evolved into its own, absurd series of books!

WORKFLOW STEP 2:
MODELING AND PENCILING

The second step in my workflow process is modeling and penciling. I don't often use a real pencil, but I use the term penciling to refer to sketches that are rough drawings, not complete ones like "inks." To add to this confusion, I also call storyboards sketches (and I draw talking eyeballs and space squids.) Apparently, I have mental issues.

Once I have storyboards (or individual drawings) completed I turn to modeling software and photography to create the first pass of finished artwork for the most complex drawings; drawings of machinery, backgrounds, and the human form.

Naturally gifted artists, or those who do this job full-time, probably skip this step; I rely heavily on models because my strength is in writing and storyboarding, but I need to get the drawings correct one way or another, and I need to get them right the first time.

For some of my graphic novels like Magnum Skywolf and Ethel The Cyborg Ninja, I draw spaceships or helicopters in pre-production and then later sculpt models out of clay.

I photograph my clay models with a phone and import them into Photoshop for penciling. You can also use 3-D modeling software to create your machines or human figures. I use clay (for machines) because it's fast, cheap, and efficient. I'm not a good sculptor, but the designs are good enough to use as drawing references.

Using the digital drawing tools featured in this book results in good looking pages that drive the story and, hopefully, entertain and engage the reader. I save all of my 3-D models and sculptures for future drawings and organize them.

As previously demonstrated on page 44, Clip Studio is a powerful, recent addition to my toolbox that I enjoy working with, especially with human forms. I often photograph myself or friends for modeling assistance too.

Depending on the book and the level of detail required for each page, I can add multiple pencil layers on top of each other as I work out and refine the details. Things like eyes, hair, clothes, weapons, mouths, backgrounds, and other details are time-consuming to get right. I'll often try different variations of things like mouthes on different layers and then select one.

A cartoon-style book like Operation Teacup Cherry Blossom may have one storyboard layer, a single pencil (sketch) layer, and an inking layer; effects and dialog are added last.

A more complicated book like Magnum Skywolf or Ethel the Cyborg Ninja 2 has more intricate artwork, more machinery, more characters, and complex backgrounds. A single page of Ethel might have a storyboard layer, numerous pencil layers, and two or three inking layers plus effects and dialog layers.

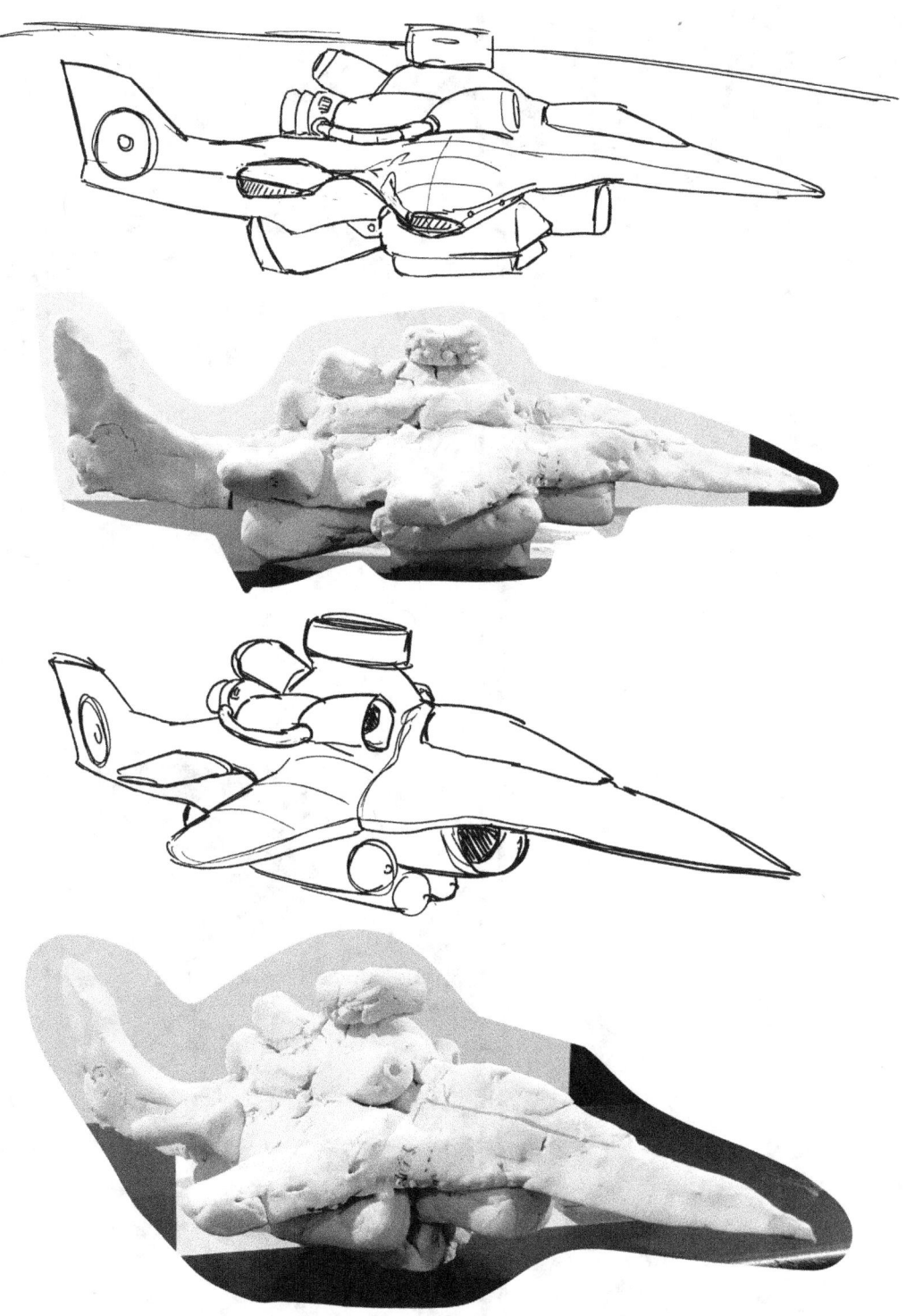

Pictured: The Magnum 9000 clay model for **Magnum Skywolf** is photographed and digital sketches are created over it.

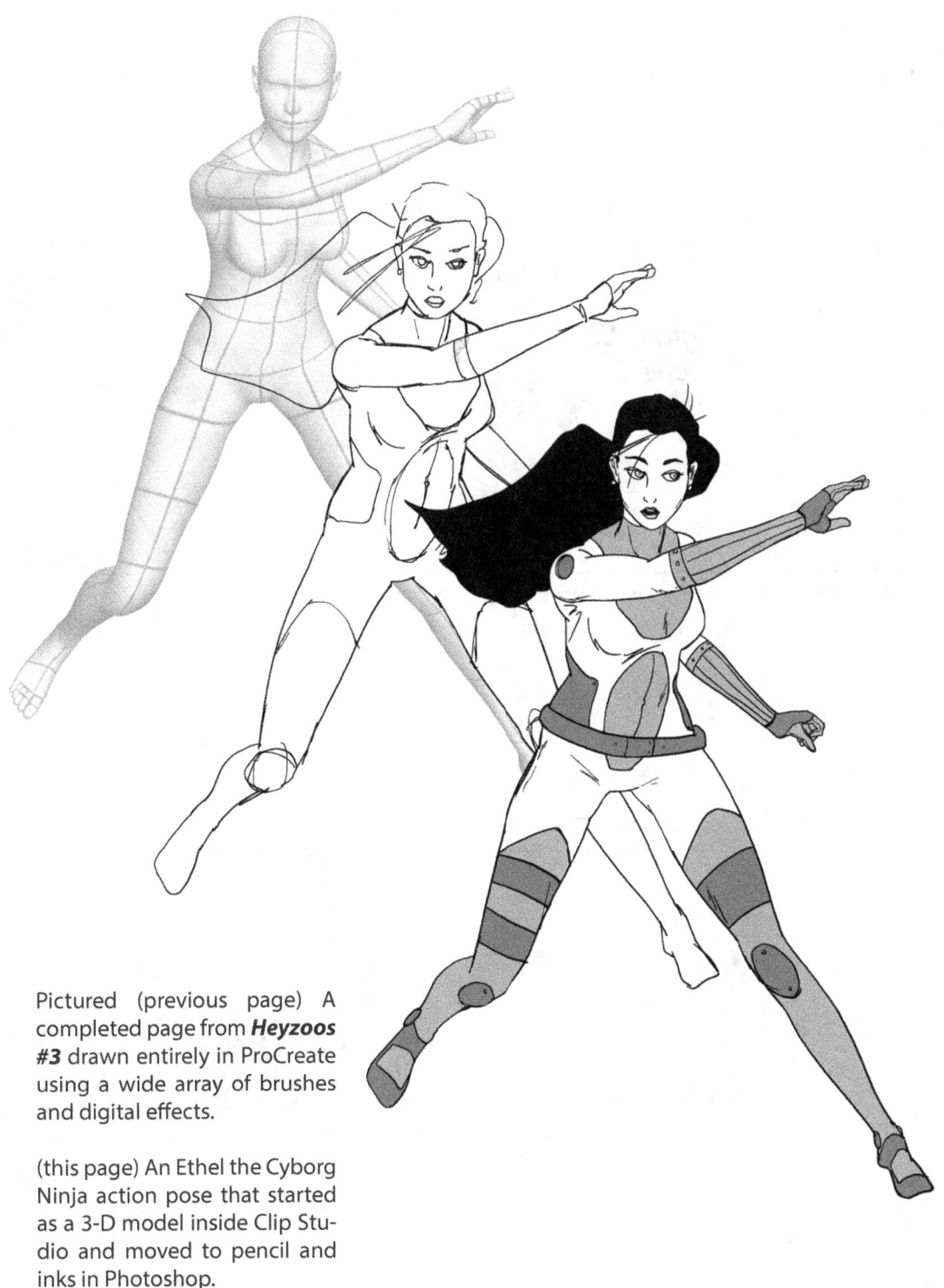

Pictured (previous page) A completed page from **Heyzoos #3** drawn entirely in ProCreate using a wide array of brushes and digital effects.

(this page) An Ethel the Cyborg Ninja action pose that started as a 3-D model inside Clip Studio and moved to pencil and inks in Photoshop.

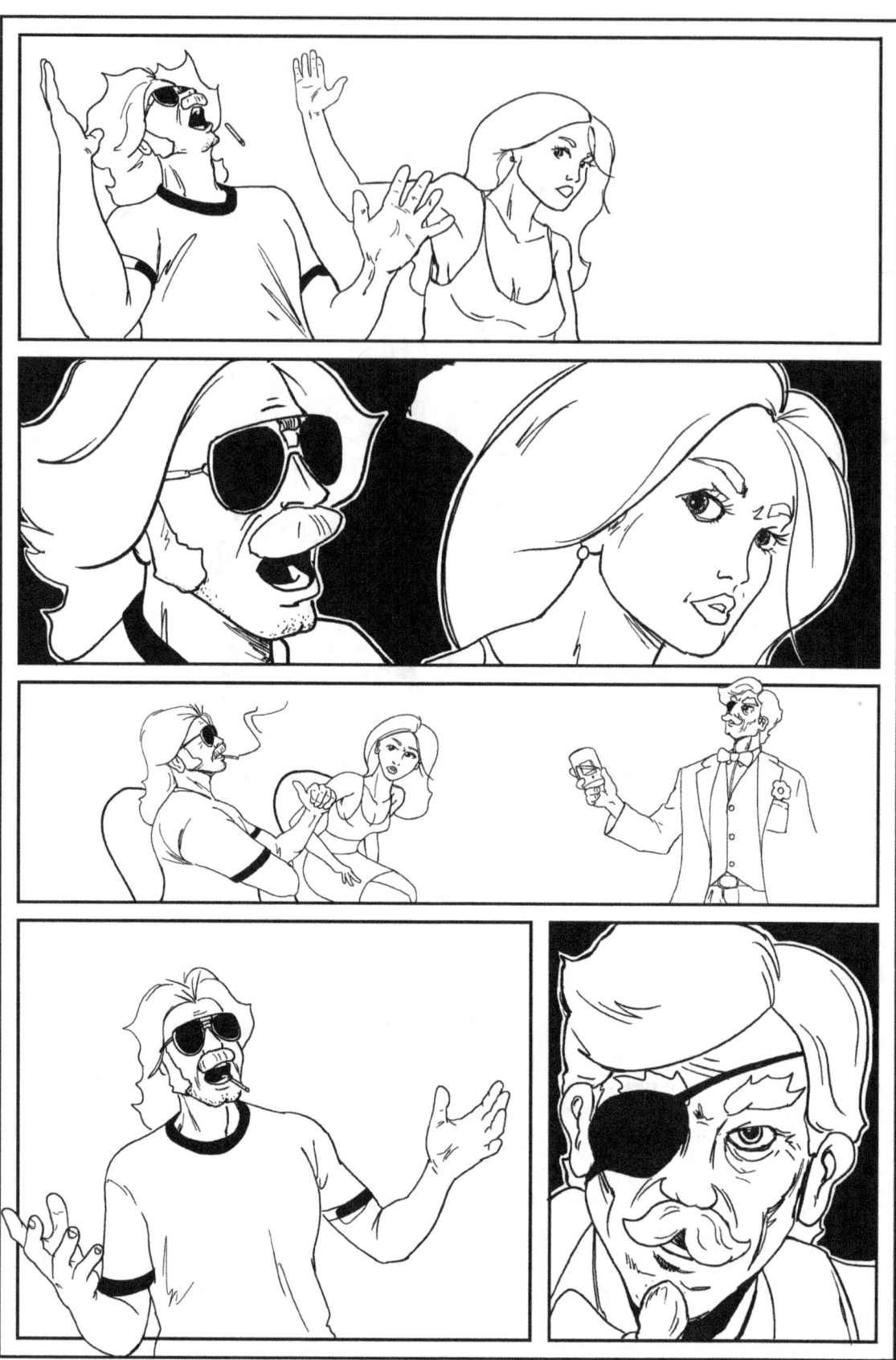

WORKFLOW STEP 3: INKING

The third step in my process is one that I call inking, though you could also refer to it as refinement. I go into my half-complete pages and "ink" them by creating a layer of smooth, refined lines that will be the completed lines that viewers see when they read my book.

Inking is one of the most time-consuming steps in this entire process because there is no limit to the amount of detail and refinement that I can add to pages and drawings before I consider them to be complete. At some point, I need to say "enough is enough; this looks good" and move on to Step 4.

Comic book artists have been working with inks since the dawn of time. Traditionally, inkers "trace" over the pencil lines with ink and add depth, contrast, and blacks to line drawings. Often, artists work in teams with pencilers and inkers creating pages in tandem.

In the digital realm, there is no need for real inks, but rather a finished layer of refined drawings that serve as inks. Artists who self-publish need to pencil, ink, and complete their projects without a team of people, and digital drawing tools allow them to do it alone. As demonstrated in this book, digital drawing programs have streamlined the creative process!

Artists can "ink" their work in any number of ways using a variety of software programs; I use Photoshop because I'm most familiar with it, though I am also using ProCreate nowadays. Regardless what software package you use, I always recommend sticking with what works best for you (but don't be afraid to learn new things!)

Once inks are complete, I save my work and sit on it for a few days. I usually set my schedule and am rarely in a rush to publish a book. I don't like rushing to complete artwork (haste makes waste.)

In my experience, I like to complete a page (or drawing) and then walk away from it for a day. I'm always amazed at how different my drawings look to me the next day. I'm not sure how my brain works, but sitting on stuff makes for better art after I've had a chance to digest it and think about it differently.

More often then not, I'll look at my inks later in the week and go back in to clean up errant lines or fix the eyes. Eyes, in particular, seem to be the most difficult thing to get right the first time, perhaps I need more practice. I find that my eye (the reader's eye) is immediately drawn to the character's eyes thus making eyes the most important part of any drawing!

My inks for Magnum Skywolf are pictured on the previous page. I have not added his T-Shirt logo, nor have I completed shading, backgrounds, or effects. I reserve those for Step 4!

STEP 4 - FINISHING

Imagine the "finishing phase" as the last part of a race when you're exhausted, drenched in sweat and ready to collapse. The end is within sight, but you still need to cross the finish line. After the long journey, your legs are tired and your lungs hurt, it's painful and requires every ounce of effort but worth it if you hope to win.

If inking is a challenging part of my workflow, then finishing is ultra-challenging! ULTRA-CHALLENGING! (shout with reverb for bonus effect.)

Finishing is the most grueling part of this entire process because I want to be done with my art and move onto the next thing, but I still need to complete the job. Every detail has to be finalized and done correctly, then checked over and over again (and even then, I still make mistakes.) The final product after the finishing stage is what the readers will see. Once the book is printed there's no turning back!

I usually save things like shading, grayscale, action-lines, and final dialog for the finishing phase because there's no sense in adding details if the drawings are going to change beforehand. From the first page to the last, all of the plot, writing, and dialog should make coherent sense before completion. I don't often work in color, but when I do that also takes place during finishing.

As seen on the next page, I refined the Magnum Skywolf artwork by adding background effects, logos, grayscale, and refinements that guide the reader's eye through the story and accentuate the humor. I always wait until the entire book is in the "finishing phase" before finalizing storyline and art consistency. There's nothing worse than an inconsistent book!

Another big part of my finishing process is saving and creating backups. The last thing that any of us want to do is lose artwork or accidentally collapse a Photoshop document and save it over the layered file (I have done this countless times.) When tired and moving quickly to finish a book, errors are easy to make.

I save my Photoshop documents as .PSD files in layers which allows me to go back in and clean up panels and adjust dialog without affecting the rest of the artwork. I also save versions of my work if I need to go back to an earlier version, which happens frequently. Photoshop gives creators a "save as a copy" option that conveniently makes a copy for you.

Finally, all of my finished work and rough drafts are backed up on hard drives and in cloud storage. Even though this is the finishing phase, nothing is ever really finished in the digital age.

All of my digital drawing projects, books, and artwork live in some form, somewhere, because I often re-publish, re-size, color, sell, print, and re-use artwork for other books, merchandise, and websites.

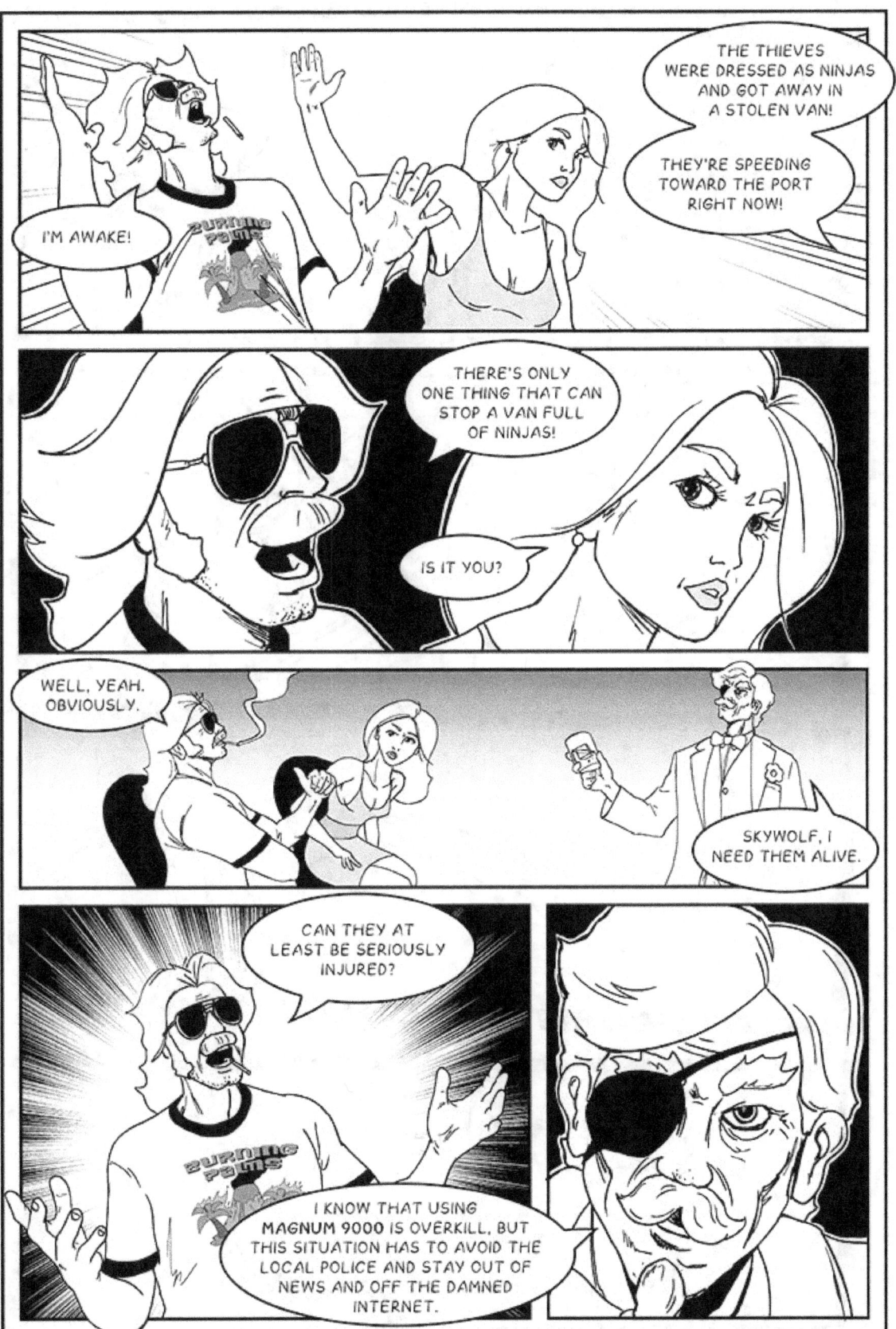

Pictured (Previous page) Storyboards for **Ethel the Cyborg Ninja #2** drawn in Adobe Draw on iPad. (Above) **Ethel 2** inks and sketch lines in Adobe Photoshop.

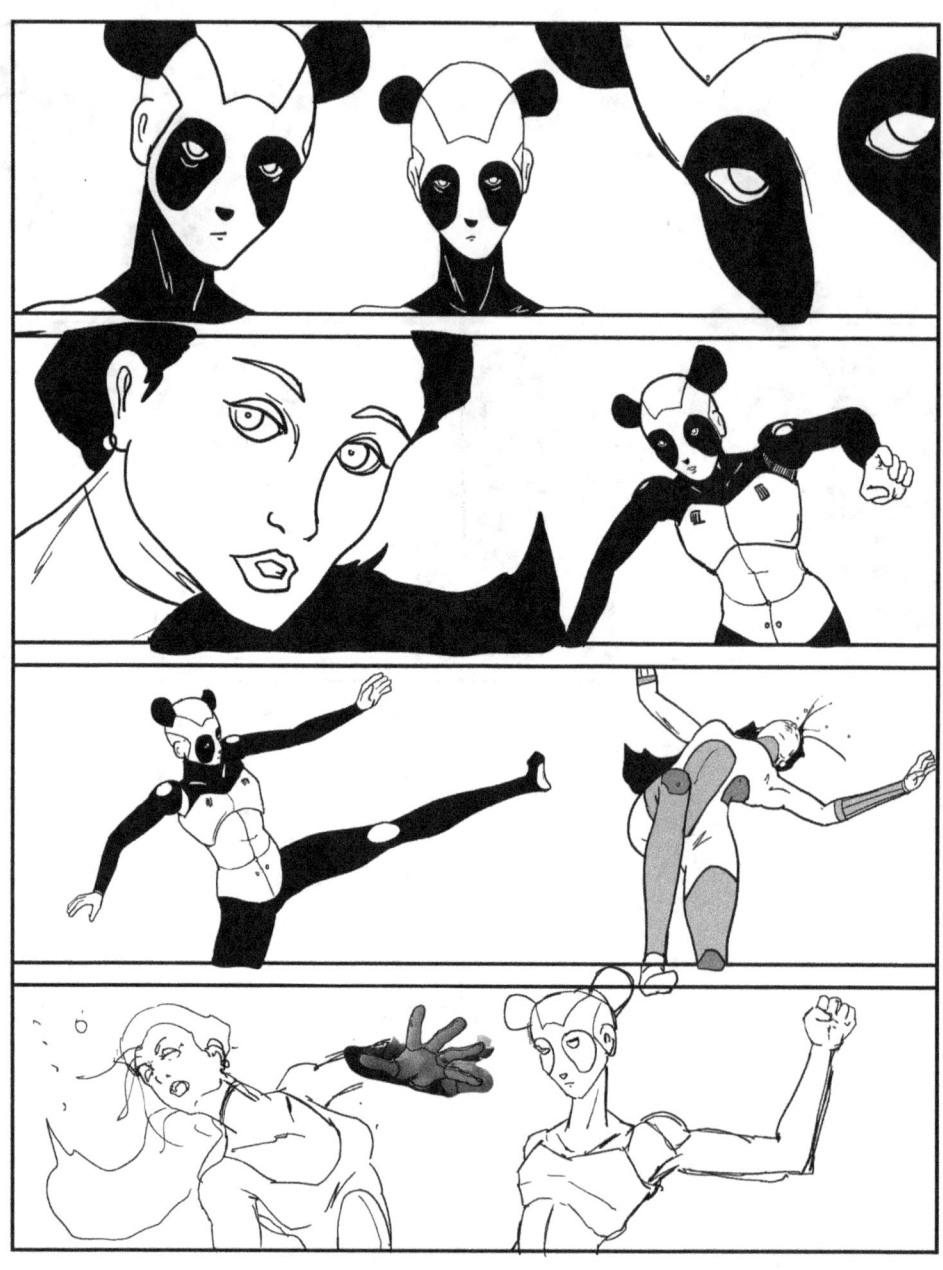

Pictured: Inks in progress. I replaced Ethel's face with the sketch from another drawing. Note that I used a photograph to model Ethel's hand.

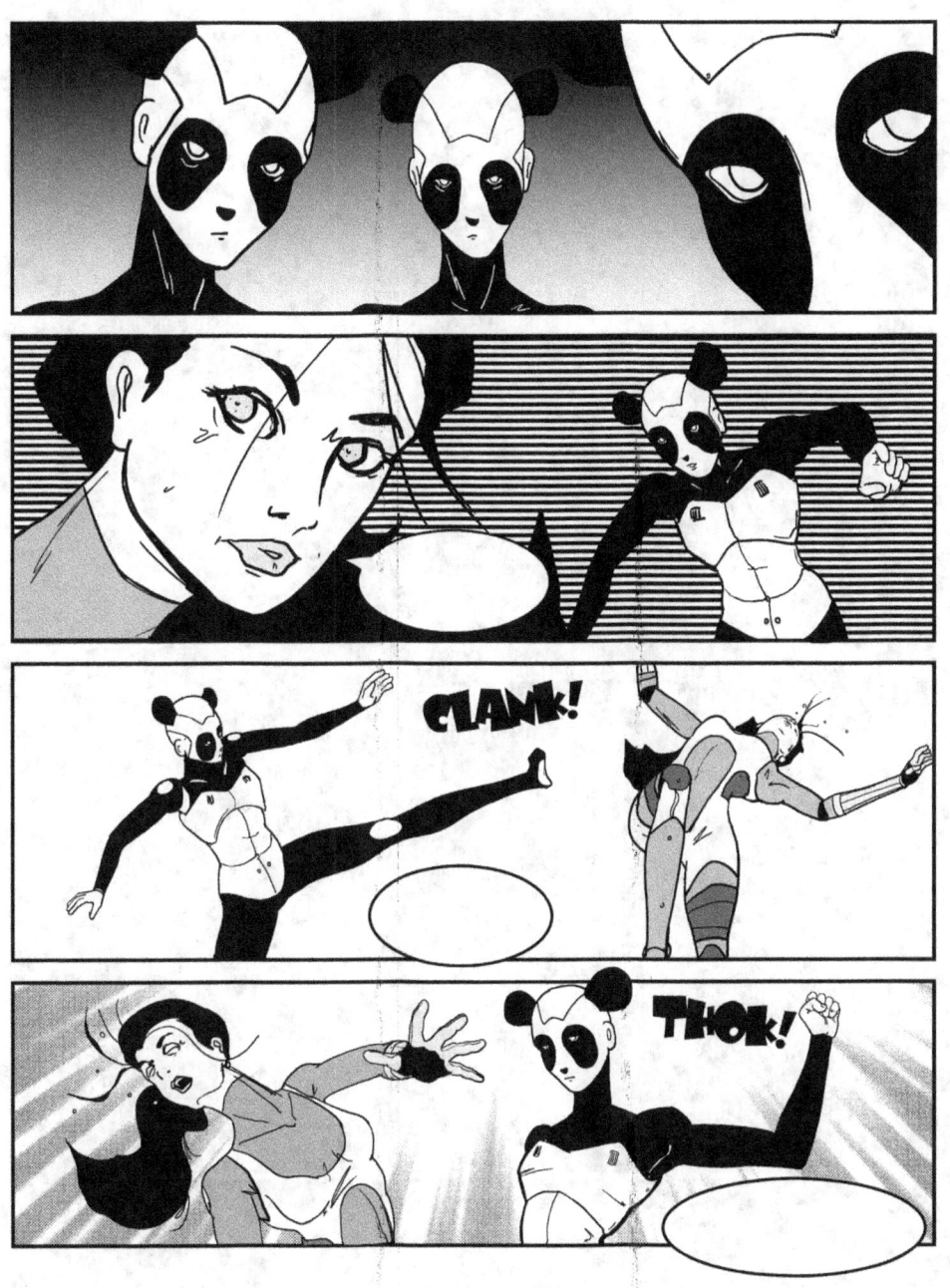

Pictured: Final page without dialog from **Ethel the Cyborg Ninja #2**.

STEP 5 - PUBLISHING

The final step in my workflow process is publishing. The moment that digital art leaves my computer, it is published in cyberspace or print somewhere. Publishing can be as simple as sharing online or as complicated as printing and selling globally.

Publishing in print is what my workflow has been engineered to do, however Internet publishing can be done any time at any step in the process.

For those who want to share their work with an audience, it is beneficial to publish digitally and share often. Viewers, readers, and followers love to see work in progress. I often share sketches of my work in progress on Twitter and Instagram.

More recently I have been publishing drawing time-lapse videos from ProCreate to platforms like TikTok, Instagram and YouTube. I will also film myself drawing on iPad or real paper from time to time. People like to see how artists work.

Publicity and social media marketing is a critical part of the self-publishing process. Creating work in a vacuum results in zero publicity. Even if it's hard to do, learn to share your process with others.

All of the mobile-based drawing tools covered in this book have "share" buttons that will send your drawings somewhere (frequently by accident,) whether that be Twitter, Instagram, e-mail, or your hard drive.

When you post a drawing on the Internet, it is public and fair game to be viewed, stolen, or shared again by people around the world. Always think twice before you post anything on the Internet!

Sharing drawings online can be a lot of fun. I recommend keeping them all in one place; for example, use one Twitter or Webtoon account, so that people can discover your work and follow to see more of it. It is easier for followers to follow you if your stuff is in one spot.

Publishing books is more complicated but not impossible. As of this writing, I publish my comics exclusively through Amazon's Kindle Direct Publishing. Much can be learned by reading Amazon's Kindle publishing site and guidelines. You'll need huge resolution files for print.

PLACES TO SHARE ARTWORK

- Twitter
- Instagram
- TikTok
- Webtoon
- YouTube
- Twitch
- Facebook
- Your Own Website

Screenshot from within Adobe Draw on my iPad shows the share options that include opening inside Photoshop, saving on the drive, and saving to Adobe's Creative Cloud storage. You can also send your art directly to Behance, which is Adobe's art sharing service. From here I can send this sketch of Ethel the Cyborg Ninja anywhere!

Pictured: A drawing of Edit-Station 1 created in Kids Doodle on iPad. Notice the little paper airplane icon on the bottom right. That icon brings up the "share menu" as pictured on the bottom left. All drawing programs have a feature like this that allows easy sharing to friends over messaging, e-mail, social media, and local hard drives. It has never been easier to share everything with everyone! Plan before you post and engage followers with great artwork and a behind-the-scenes adventure.

Pictured: A screenshot of the Line Webtoon page for my comic strip series, Old Timey Pictures with Silly Captions. Building an Internet following is difficult. Webtoon is easy to use and great for publishing, but difficult to grow an audience. Don't let low numbers discourage you, keep posting and push ahead regardless of feedback. Search Webtoons.com for "Old Timey Pictures," and you'll find it and laugh out loud. It's very inappropriate.

CHAPTER 6: PRACTICE!

Hopefully, this book proved itself useful in some way; perhaps you enjoyed looking at the silly pictures of broken computers and cyborg ninjas.

Whether you draw digitally or in real life with pencils and markers, the most important tool is not your iPad or digital pen. It is you, and you require practice! Get out there and make mistakes, then learn from them.

That sounds like a lame motivational poster, but it's true. Just a few decades ago, artists had no digital tools, no camera phones, no modeling software, and no multi-layer drawing programs.

Old-school cartoonists, comic book artists, and manga creators were good because they had to be, nobody would publish them if they weren't good. No amount of software is a supplement for real talent and dedication to the craft (but these days, you can publish anything.)

It's easy to fall into a digital rut and rely on the tools to do the work for you. Modern software will practically draw itself, but that won't make you any better. Use the tools to practice, get inspiration, and enhance your ideas, not to replace them.

I rely on modeling software and camera phones to get things right the first time and increase my drawing consistency, but I'm also practicing and learning new things all the time. In time, I won't need to rely on them at all.

Drawing something over and over again is how we, as artists, learn to draw it. Photograph your hand, trace it, draw it a hundred times. You'll eventually memorize it.

Software like Photoshop, ProCreate, and Clip Studio is powerful and effective, especially when creating work for sale or print work. All of the high-end, professional software packages require practice and a great deal of learning to use properly; they are complicated tools. Consider reading or watching tutorials before diving into something like Photoshop.

Publish your work online and build a social media following. We're all sick of social media over-saturation (or at least I am), but it remains an important part of building your name, your brand, and your portfolio, even if it's just for fun.

Thank you for reading my book! This is the first book in the How To Draw by Mark Bussler series. I also create specific drawing books like How To Draw Pandas By Mark Bussler and How to Draw Dolphins by Kawaii Ocean and How to Draw Manta Rays by Kawaii Ocean (my kids brand.)

Get out there and draw anything and everything that comes into your head. Practice! Good luck!

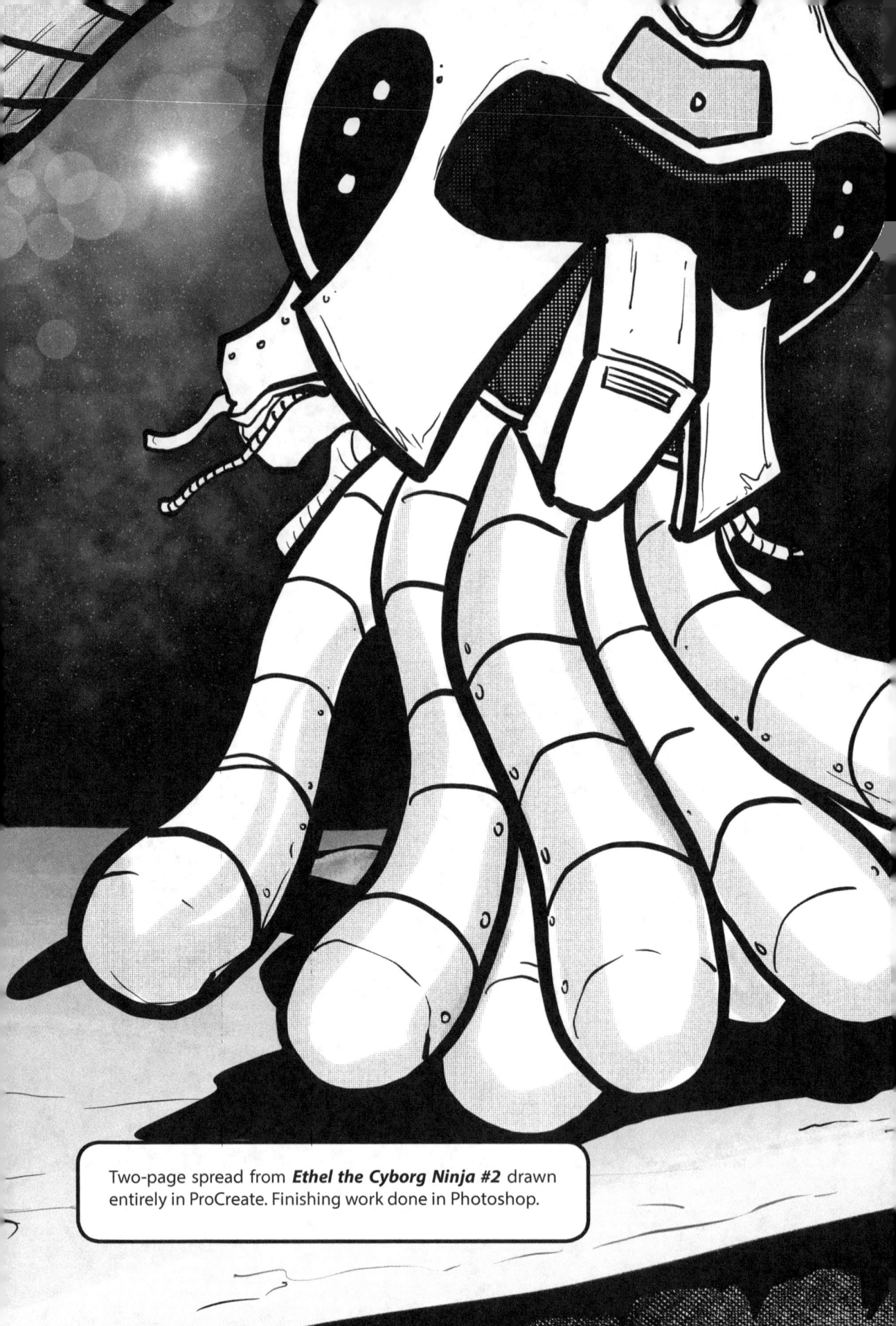

Two-page spread from *Ethel the Cyborg Ninja #2* drawn entirely in ProCreate. Finishing work done in Photoshop.

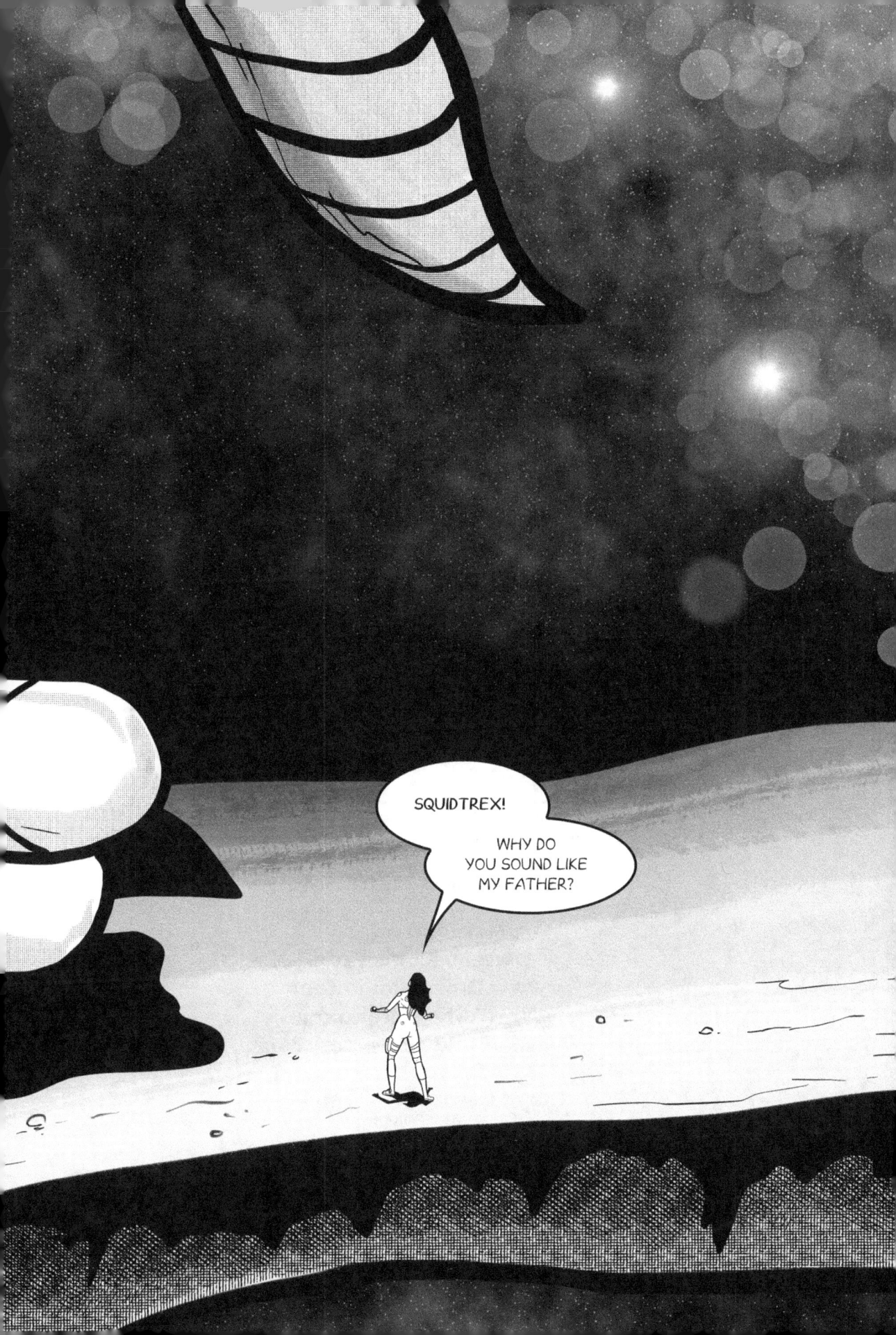

ABOUT THE AUTHOR

Mark Bussler is the prolific artist, filmmaker, and writer behind numerous science fiction, history, photography, gaming, and how-to-draw books. His works include *The World's Fair of 1893 Ultra Massive Photographic Adventure* series, *Ethel the Cyborg Ninja*, *All Hail the Vectrex*, *How To Draw Digital by Mark Bussler*, *Chicago 1933 World's Fair: A Century of Progress in Photographs*, *Old Timey Pictures with Silly Captions*, and more. Mark is the creator of the Turbo Volcano clothing brand and runs **Classic Game Room Publishing**.

Many of his film projects can be seen on PBS that include *Expo: Magic of the White City* narrated by Gene Wilder, *Horses of Gettysburg*, and *Westinghouse*. Mark created *Classic Game Room* in 1999, the longest-running Internet video game review show in the world. He returned to documentary filmmaking in 2019 for a film titled *A Good Time at the 1939 New York World's Fair*.

Mark draws in digital and physical media and often combines the two. His designs appear on thousands of clothing products, shirts, mugs, and prints. As of this publication, he is working on numerous comic books and manga series, including *Omega Ronin*, *Magnum Skywolf*, and *Robot Kitten Factory*.

In his spare time (which isn't much), Mark is an avid reader of classic science fiction, comic books, manga, and antique newspapers. He lives in deep space with his family and a psychotic dog. Mark is the editor-in-chief of **80sComics.com** and continues to produce *80sComics* video content that runs on YouTube and TikTok.

Subscribe to Classic Game Room Newsletter

www.ClassicGameRoom.com/subscribe

Mark's other projects:
www.80sComics.com
www.OmegaRonin.com
www.TurboVolcano.com
www.RobotKittenFactory.com

How to Draw Digital by Mark Bussler
2019 Revision
Copyright © 2019 Inecom, LLC.
All Rights Reserved

OTHER BOOKS & GRAPHIC NOVELS BY MARK BUSSLER

Ultra Massive Video Game Console Guide Volume 1

Ultra Massive Video Game Console Guide Volume 2

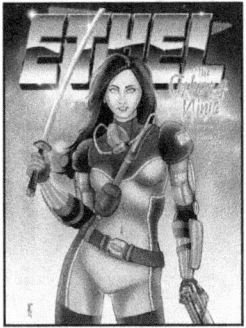
Ethel the Cyborg Ninja Book 1

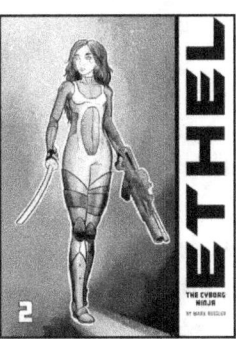
Ethel the Cyborg Ninja 2

Lord Karnage 1.5 Special Edition

Retromegatrex Volume 1: The Lost Art of Mark Bussler 1995-2017

Heyzoos the Coked-Up Chicken #1 Special Edition

Heyzoos the Coked-Up Chicken #2 Special Edition

Surf Panda #1

Heyzoos the Coked-Up Chicken #3

World's Fair of 1893 Ultra Massive Photographic Adventure

The White City of Color: 1893 World's Fair

How to Draw Dolphins by Kawaii Ocean

How To Draw Pandas By Mark Bussler

1939 New York World's Fair: The World of Tomorrow in Photographs

Old Timey Pictures With Silly Captions Volume 2

www.ingramcontent.com/pod-product-compliance
Lightning Source LLC
Chambersburg PA
CBHW080923240526
45472CB00026B/1826